COWBOY CRAFTS

COWBOY CRAFTS

Projects with a Western Flair

▲▲▲▲▲▲▲▲

JAKE McCOWEN

A STERLING/CHAPELLE BOOK
Sterling Publishing Co. Inc. New York

For Chapelle Ltd.

Owner: Jo Packham

Staff: Trice Boerens, Rebecca Christensen, Holly Fuller, Cherie Hanson, Holly Hollingsworth, Susan Jorgensen, Lorin May, Jackie McCowen, Tammy Perkins, Jamie Pierce, Leslie Ridenour, Amy Vineyard, Nancy Whitley, and Lorrie Young

Designers: Ann Benson, Trice Boerens, Polly Carboneri, Holly Fuller, Jamie Pierce, Florence Stacey, Edie Stockstill and Glenne Stoll

Photography: Kevin Dilley and Ryne Hazen

Poetry: Don Kennington and Phil Kennington

Watercolors: Holly Fuller

The photographs in this book were taken at R C Willey Home Furnishings , Cowboy Tradin' Post and Fronteir Barber Shop, and at the home of Edie Stockstill. Their cooperation and trust are sincerely appreciated.

Library of Congress Cataloging-in Publication Data

McCowen, Jake.
 Cowboy Crafts : projects with a western flair / by Jake McCowen.
 p. cm.
 "A Sterling/Chapelle book."
 Includes index.
 ISBN 0-8069-0816-5
 1. Handicraft—West (U.S.) 2. Cowboys in art. 3. Wearable art—
United States. I. Title.
TT157.M445 1994
745.5 —dc20
 94-16837
 CIP

10 9 8 7 6 5 4 3 2 1

Published by Sterling Publishing Company, Inc.
387 Park Avenue South, New York, N.Y. 10016
© 1994 by Chapelle Ltd.
Distributed in Canada by Sterling Publishing
C/o Canadian Manda Group, P.O. Box 920, Station U
Toronto, Ontario, Canada M8Z 5P9
Distributed in Great Britain and Europe by Cassell PLC
Villiers House, 41/47 Strand, London WC2N 5JE, England
Distributed in Australia by Capricorn Link (Australia) Pty Ltd.
P.O.Box 6651, Baulkham Hills, Business Center, NSW 2153, Australia
Printed and bound in China.
All Rights Reserved

Sterling ISBN 0-8069-0816-5

INTRODUCTION

The cowboy is a dying breed,
 I've heard some people say,
like as if we don't belong
 here in their land.

We wear hats and boots and spurs
 and we use some strange words too,
like we say that
 "We are riding for the brand."

It's hard to put on paper
 the things that's in my heart.
It's just about
 impossible it seems.

I keep on writing down
 but it's only words I've found
and there ain't no way
 that words can feel a dream.

You've got to ride out there yourself.
 You've got to face the herd,
accept the cold the thirst,
 the dust, the heat.

Love that life more than money.
 Love that freedom more than gold,
Sit straight and tall
 upon your saddle seat.
 —Don Kennington

CONTENTS

WEARABLES

Beaded Denim Shirt......11
Shoot-Out Shirt Pockets......13
Cavalry Shirt......17
Cow Punchin' PJ's......19
Southwest Bag......21
Beaded Hatband......25
Beaded Watchband......26
Beaded Earrings......27

FOR THE BUNKHOUSE

Desert Flowerpots......31
Li'l Boots Shelf Liner......33
Paper Poetry Frame......35
Beaded Paper Frame......38
Ranch Journal......39
Xmas Tree Stocking Holder......41
Darn Good Doorstop......43
Taos Light Switch Covers......46
Sunflower Pillow......51
Hang 'Em Up Coat Rack......53
Ranch Numbers......55
Bandanna Window Valance......56
Fishes in Stitches......58
Bunkhouse Bookends......61
Cross-Stitch Sampler......64
Quilted Table Runner......69
Quilted Note Card......71
Quilted Hot Pad......72
Cross-Stitch Cowgirl......73
Dream Catcher......79
Western Lampshade......81
Country Cupboard......84
Cowboy Quilt......86
Beaded Picture Pins......87
Red-Pepper Door Hanger......89
Frontier Picture Frame......90
Covered Wagon Mailbox......92

FOR THE CHUCKWAGON

Longhorn Bar-B-Q Apron......97
Leather Jar Labels......100
Jar Dangles......103
Rancher Recipes......104
Place Mat & Napkin Ring......106
Clay Candleholders......107

BUCKAROO BONUS

Pony Express Wrapping Paper......111
Possibles Box......113
Mustang Planter......115
Sachets......119
Prickly Note Cards......121
Canoes......123
Tepee......126
Log Cabin......128
Snakes......131
Wagon Planter......134
Maverick Magnets......136
Gourd......138
Old Glory Chair......139
Patriotic Wall Hangin's......140

General Instructions......141
Metric Equivalence Chart......143
Index......144

There's more

 to being a cowboy,

than wearing fancy clothes.

You've got to ride

 in heat and dust

and when the "Norther" blows,

you've got to learn

 to read a cow

and throw a lariat.

And a "jillion" other

 little things

you don't see on a TV set.

 —Don Kennington

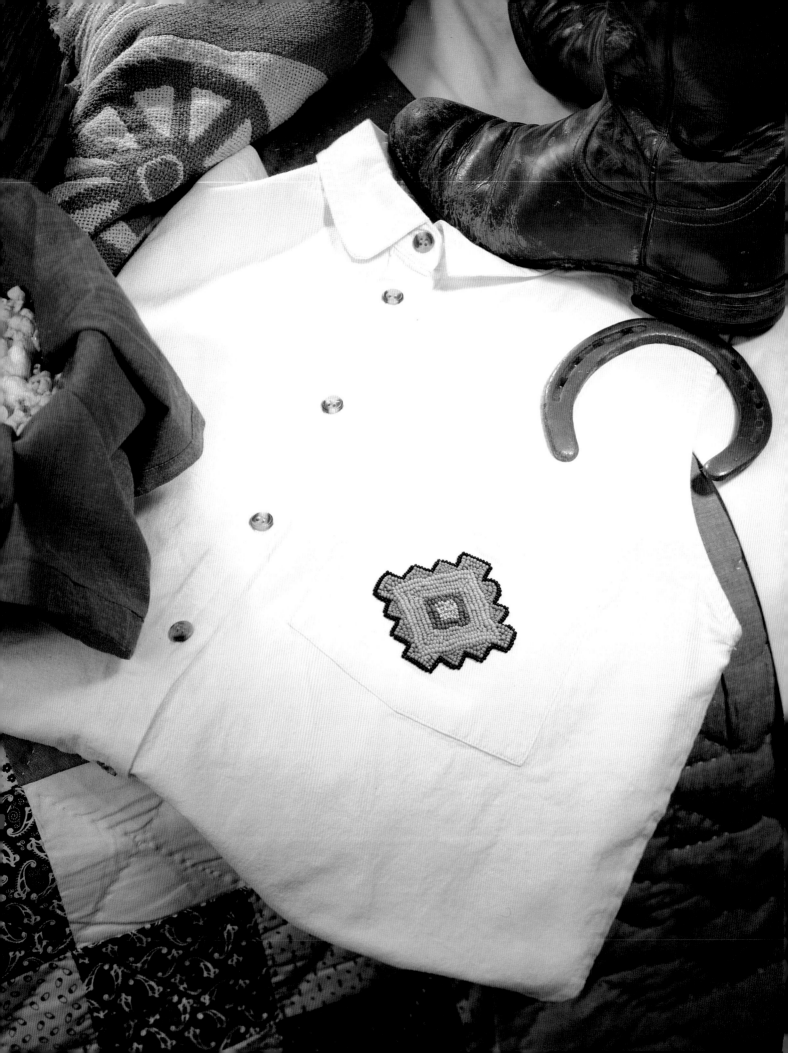

BEADED DENIM SHIRT

MATERIALS

One purchased shirt with front pocket
10/0 seed beads:
 1 oz. black
 1 oz. light blue
 1 oz. cream
 1 oz. lavender
 1 oz. green
 1 oz. blue
 1 oz. light blue
 1 oz. purple
 1 oz. pink
Beading needle and thread
Dressmaker's pen

DIRECTIONS

1. Using dressmaker's pen, transfer beading pattern to shirt pocket.

2. Stitch the beads onto the shirt according to the pattern.

3. Gently launder shirt to remove pen lines.

BEADING PATTERN

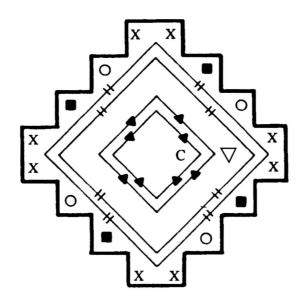

—— LINES OF BLACK BEADS ■ FILL WITH BLUE BEADS

— LINES OF LIGHT BLUE BEADS ++ LINES OF LIGHT BLUE BEADS

C FILL WITH CREAM BEADS ▲ LINES OF PURPLE BEADS

X FILL WITH LAVENDER BEADS ▽ FILL WITH PINK BEADS

O FILL WITH GREEN BEADS

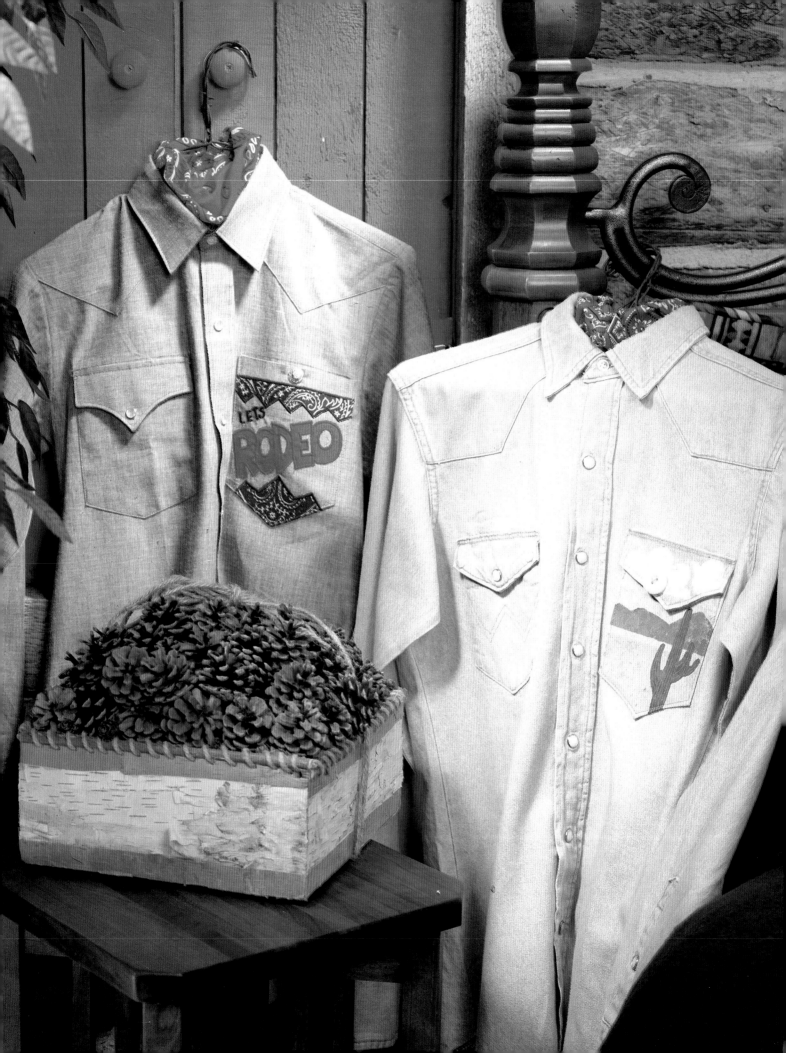

SHOOT-OUT SHIRT POCKETS

Desert-Stenciled Shirt Pocket
MATERIALS

One purchased long-sleeved denim shirt with front
 pocket; matching thread
Pencil and tracing paper
Manila folder
Craft knife
Piece of cardboard
Straight pins
Fabric paints: green, brown, blue, white, gray, and tan
Stencil brush
One 1"-diameter yellow button
Needle and yellow thread
Seam ripper
Iron

DIRECTIONS

1. Remove the pocket with seam ripper, making sure
that you do not cut the shirt or the pocket. Remove
any loose threads and press open all seam allowances;
set aside.

2. Trace cloud/mountain/desert and cactus patterns.
Transfer patterns to manila folder. Cut out areas to be
stenciled.

3. Slide cardboard inside shirt pocket under area to be
painted. Stick straight pins through fabric into card-
board to help hold fabric in place.

4. Stencil clouds white, mountains blue, and desert
tan; let dry. Place cactus pattern over dried, painted
mountain and desert. Stencil cactus green; see dia-
gram. Let dry. Accent cactus by painting thin gray
lines on it.

5. After the pocket is completely dry, press the seam
allowances back into place. Center the pocket on the
shirt and sew it on with matching thread.

6. Sew yellow button on pocket for sun as desired.

CACTUS PATTERN

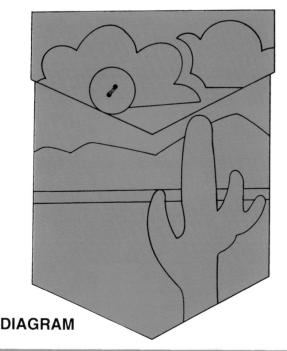

DIAGRAM

Rodeo Shirt Pocket
MATERIALS

Purchased long-sleeved denim shirt with front
pocket; matching thread
Scraps of red fabric; matching thread
Scraps of blue bandanna fabric; blue thread
Scraps of fusible webbing
Iron
8" x 10" piece of tear-away
Sewing machine with embroidery foot
One ½"-diameter silver pin or button
Pencil and tracing paper
Dressmaker's pen

DIRECTIONS

1. Remove the pocket with seam ripper, making sure
that you do not cut the shirt or the pocket. Remove
any loose threads and press open all seam allowances;
set aside.

2. Trace top and bottom border, and "RODEO" pat-
terns. If needed, adjust the border patterns to fit the
width of the pocket and to allow for a ¼ " seam
allowance when pocket is reattached. Transfer pat-
terns to the fabric side (not the paper side) of fusible
webbing. Cut out; do not remove paper.

3. Fuse borders to blue bandanna fabric and
"RODEO" to red fabric. Cut out all pieces. Remove
paper backing. Arrange the fabric pieces on the pock-
et front as follows: place the top border ¾" from fold-
ed top edge of pocket, extending the side edges into
the seams; center the bottom border, extending the
bottom edges into the seams; place "RODEO" as
desired between borders. Fuse all pieces to pocket
front.

4. Place shiny side of tear-away against wrong side of
pocket front. Iron. With dressmaker's pen, write the
word "LETS" between top border and "RODEO"; see
photo.

5. Machine satin-stitch fabric pieces, stitching around
"RODEO" letters with red thread; stitch around top
and bottom edges of top border and top edges only of
bottom border with blue thread. Also with blue thread,
stitch the word "LETS"; see diagram.

6. To remove tear-away, make a small scissor cut in
center portion of stitched appliqués. Lift and tear.

7. Attach silver pin or button to center top of pocket;
see diagram.

8. Press the seam allowances back into place. Center
the pocket on the shirt and sew it on with matching
thread.

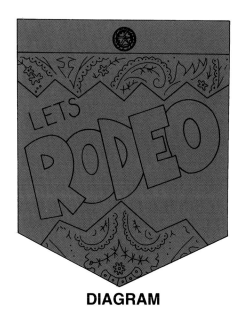
DIAGRAM

BOTTOM BORDER PATTERN

CLOUD/MOUNTAIN/DESERT PATTERN

TOP BORDER PATTERN

RODEO PATTERN

15

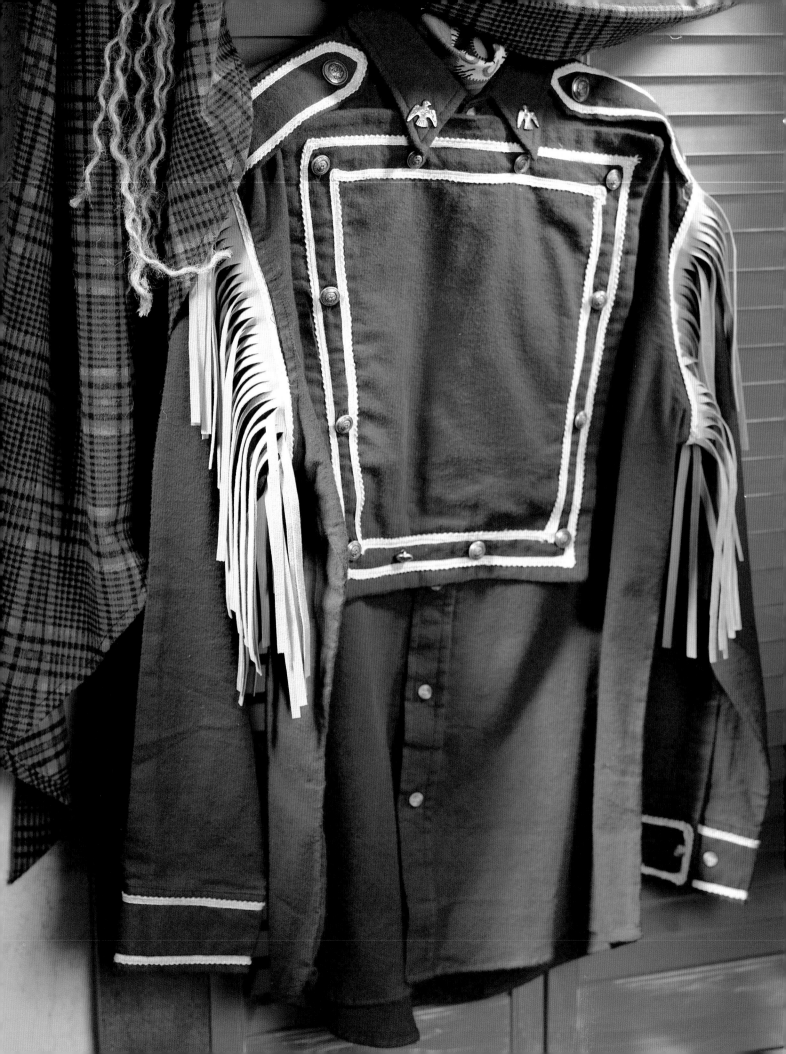

CAVALRY SHIRT

MATERIALS

One purchased long-sleeved blue flannel shirt
½ yard of matching fabric
6 yards of cotton trim
8" x 36" length of leather fringe
Twelve ½" silver military buttons
Two ¾" silver military buttons
Two silver eagle studs
Matching thread
Seam ripper

DIRECTIONS

All seams are ¼".

1. Make front panel pattern and epaulet pattern, transferring all marks. From fabric, cut two front panels and four epaulets. From shirt, remove pockets. To make front panel with right sides facing, aligning all edges, stitch, leaving small opening. Turn, whipstitch closed and press. Add cotton trim along marked lines. Mark buttonhole placements. Make buttonholes. Mark front of shirt for button placement. Set aside.

2. To make epaulets, with right sides facing, aligning all edges, stitch, leaving short end open. Turn and press. Add cotton trim along marked lines. Repeat. Using seam ripper, make opening in shoulder seam large enough to fit epaulet. Stitch in place, repeat; see photo.

3. To add leather trim, starting at seam under the arm, stitch around shoulder seam, ending under the arm. Repeat. Stitch cotton trim over stitch seam of leather fringe.

4. Add eagle studs to collar; see photo.

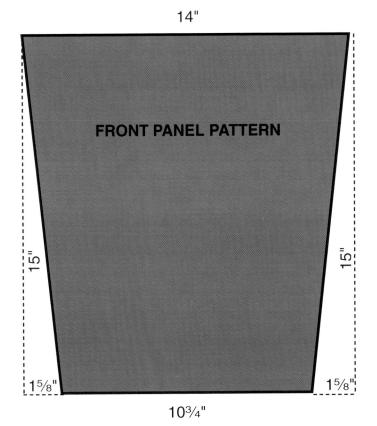

FRONT PANEL PATTERN

14"

15"

15"

1⅝"

1⅝"

10¾"

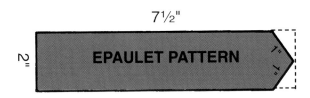

7½"

EPAULET PATTERN

2"

1"

1"

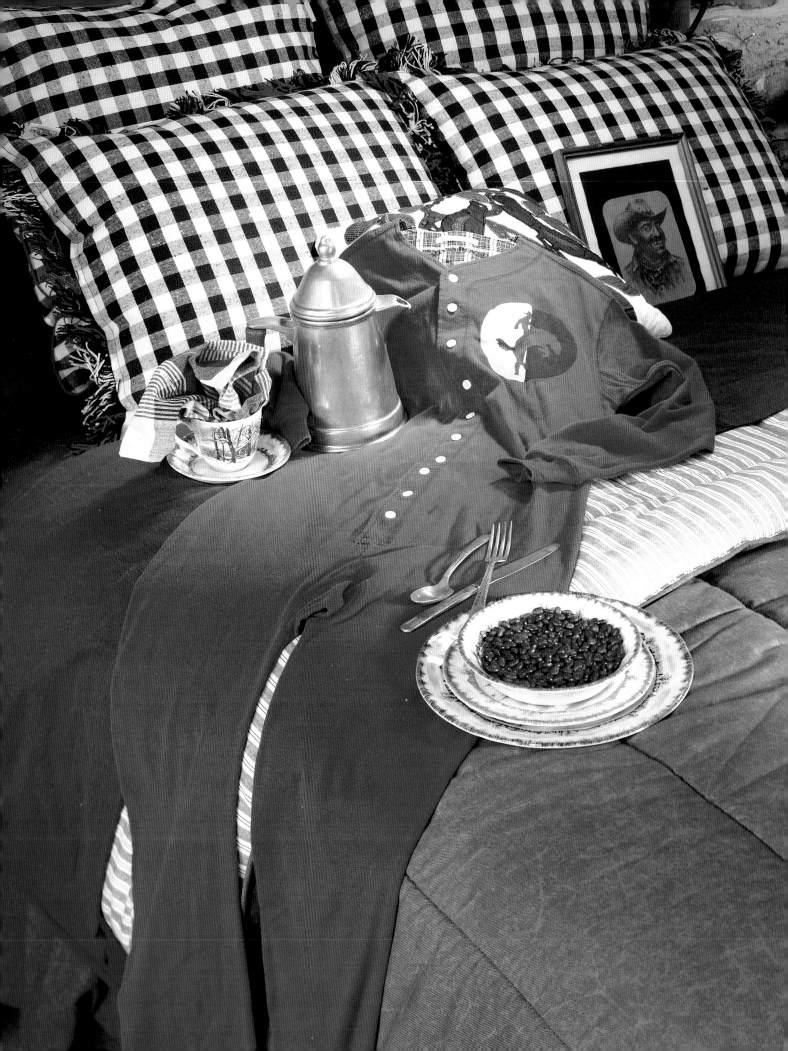

COW PUNCHIN' PJ'S

Nothing beats a good pair of old-fashioned red longjohns for warmth in winter; that's why they still make 'em! Stencil yours in two colors as shown here, or combine the stencil pattern and paint with only one color. Either way, everybody'll get a kick out of 'em!

MATERIALS

Purchased pair of red longjohns or pajamas
Pencil and tracing paper
Manila folder
Craft knife
Piece of cardboard
Straight pins
Fabric paints: blue and white
Stencil brush

DIRECTIONS

1. Trace bronco patterns. Transfer to manila folder. Cut out areas to be stenciled.

2. Slide cardboard inside longjohns under area to be painted. Stick straight pins through fabric into cardboard to help hold fabric in place.

3. Stencil right side of bronco blue; let dry. Stencil left side of bronco white; let dry.

BRONCO PATTERN

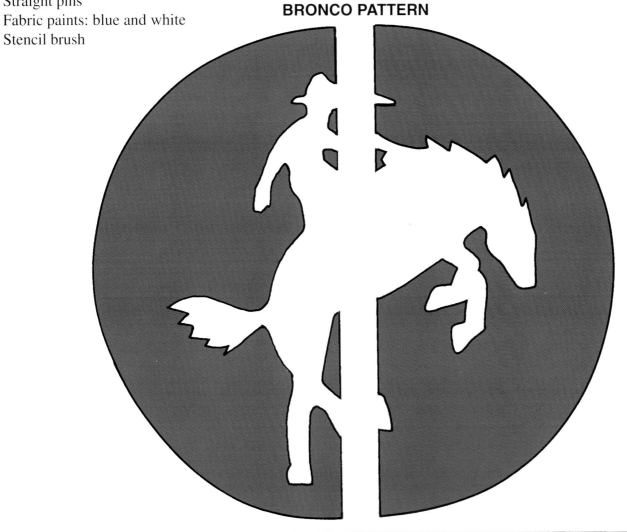

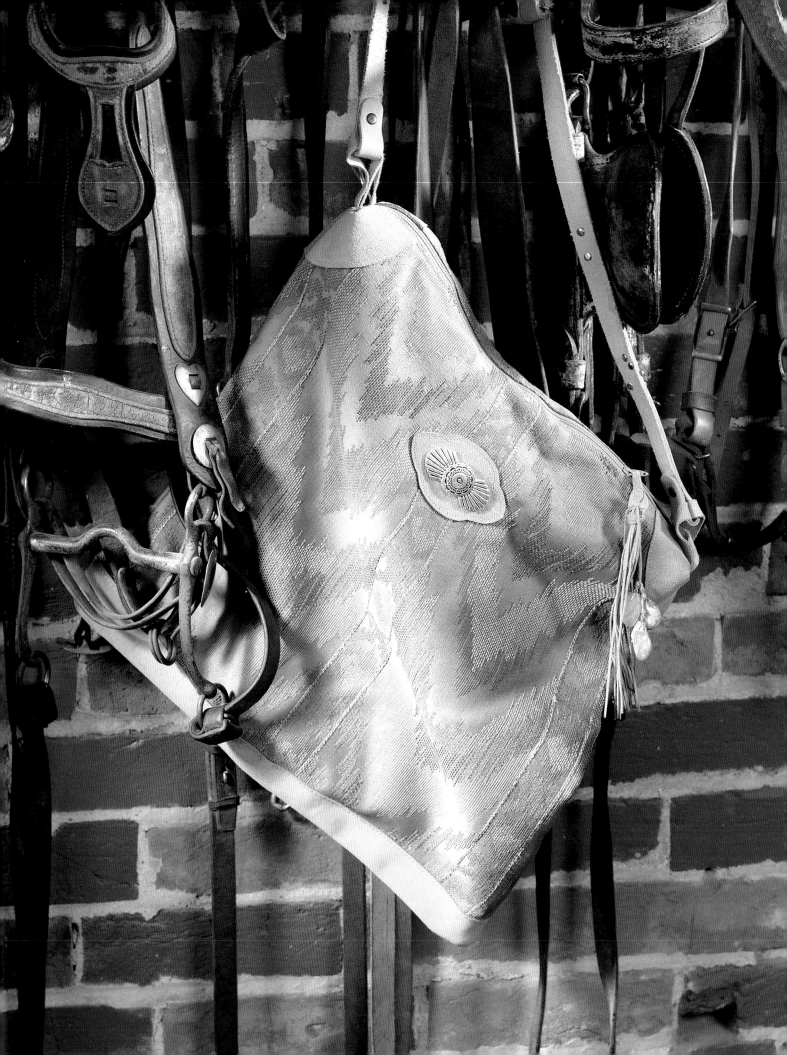

Any cowgirl would be proud to carry this good-looking tote. Navajo-style blanket fabric would be pretty, wouldn't it? You could snap the buckle off a slim, fancy Western-style belt and use it for a purse strap, if that suits you. Your local leather shop can help you find the rest of the items you need for this colorful Southwestern bag!

MATERIALS

Pencil and tracing paper
$\frac{1}{2}$ yard of Southwestern woven print fabric; matching thread
18" nylon zipper in coordinating color; matching thread
$\frac{1}{2}$ yard of tan fabric for lining
$\frac{1}{4}$ yard tan rough-out leather
Sturdy scissors
Dressmaker's pen
Purchased plain leather purse strap with snap-fastener ends
Four small Southwestern-design decorative rivets
One large Southwestern-design decorative rivet
Leather punch
One package of suede leather cord
Three purchased decorative stone pendants
Leather needle for sewing machine

DIRECTIONS
All seams are $\frac{1}{4}$".

1. From print fabric, cut two $17\frac{1}{2}$"-square pieces for bag front and back. From tan fabric, cut two $17\frac{1}{2}$"-square pieces for lining; set aside.

2. Close zipper. With right side down and edges aligned, sew bag front to zipper edge; see Diagram A-1. Fold bag front back so that right side is up and stitch along first stitching line; then stitch new line $\frac{1}{4}$" from first; see Diagram A-2. Repeat with bag back on opposite edge of zipper.

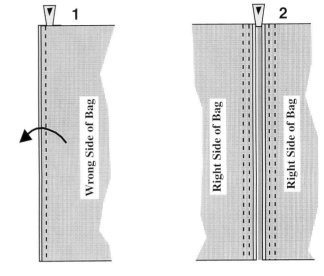

DIAGRAM A

3. Make leather corner, medallion and pendant hanger patterns on page 23. From rough-out leather, cut four corners, one medallion and one pendant hanger. Also cut four $\frac{1}{2}$" x 8" strips for handle keepers and two 2" x $17\frac{1}{2}$" bumper strips.

4. Stitch one leather corner to each top corner of bag front, aligned with zipper; see Diagram B-1. Loop one handle keeper, matching ends. Stitch to one leather corner about $\frac{1}{4}$" from zipper and $1\frac{3}{4}$" above bottom edge of corner; see Diagram B-2. Repeat with remaining handle keepers on leather corners. Cutting through fabric, leather and zipper end about $1\frac{3}{8}$" above bottom edge, cut a rectangle about $2\frac{1}{4}$" x $1\frac{3}{8}$" across two corners; see Diagram B-3. Hand-stitch firmly across zipper at top of cut to secure; see Diagram B-3. Repeat at opposite end of zipper.

5. Attach large decorative rivet to leather medallion. Stitch medallion to bag front $2\frac{1}{2}$" below zipper and horizontally centered. With long edges aligned, stitch one bumper strip each to bottom edge of bag front and back on right side.

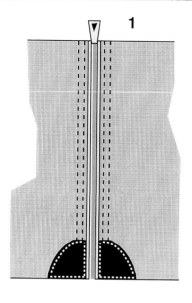
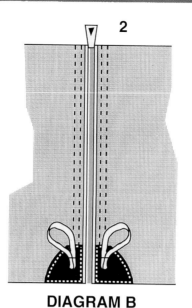
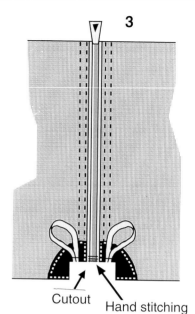

DIAGRAM B

Cutout Hand stitching

6. Open zipper. With right sides facing, stitch bag front and back together, slightly rounding bottom corners and making box pleat by pulling out and stitching across each top corner; see Diagram C. Do not turn bag right side out.

7. To make lining, stitch lining pieces together 16½" up two edges, leaving two edges open. Slide lining over bag with one open edge at top. Turn top lining edges under ¼" and topstitch to zipper. Complete stitching on lining sides, except bottom.

8. Turn bag through opening in lining. Slipstitch opening closed. Tuck lining inside bag.

9. Pull narrow end of pendant hanger through opening in zipper pull. Loop over and stitch to large end, above dot on pattern. Punch medium-size hole through dot. Cut suede cord into ten 12" lengths. Thread nine lengths through hole till ends match. Wrap remaining length around bundle and secure. Attach stone pendants to cords as desired, knotting cords to secure; see photo.

10. Attach small decorative rivets to purse strap as desired; see photo. Pass snap ends of strap through handle keepers and snap.

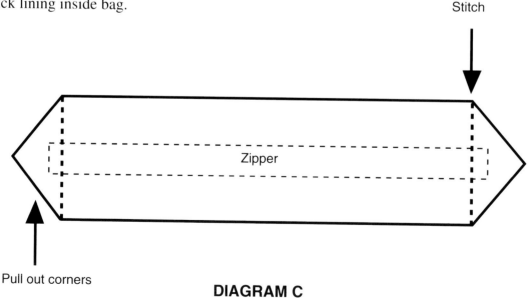

Stitch

Zipper

Pull out corners

DIAGRAM C

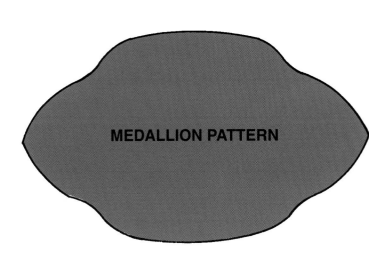

MEDALLION PATTERN

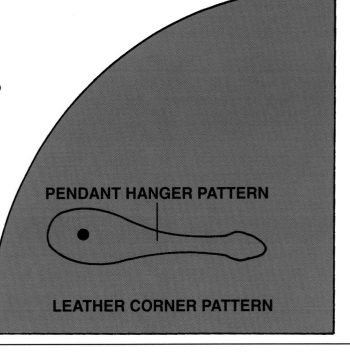

PENDANT HANGER PATTERN

LEATHER CORNER PATTERN

BEADED HATBAND PATTERN

(Instructions for Beaded Hatband are on page 25.)

Start here

End here

⊕ AQUA
⊗ PURPLE
⊛ DARK GREEN
⊙ GOLD
⊙ MAROON
⊖ LIGHT BLUE
⊙ YELLOW
⬤ BLACK
⊖ RED
⊖ SILVER
◎ ORANGE
⬤ ROYAL BLUE
⓪ COPPER

23

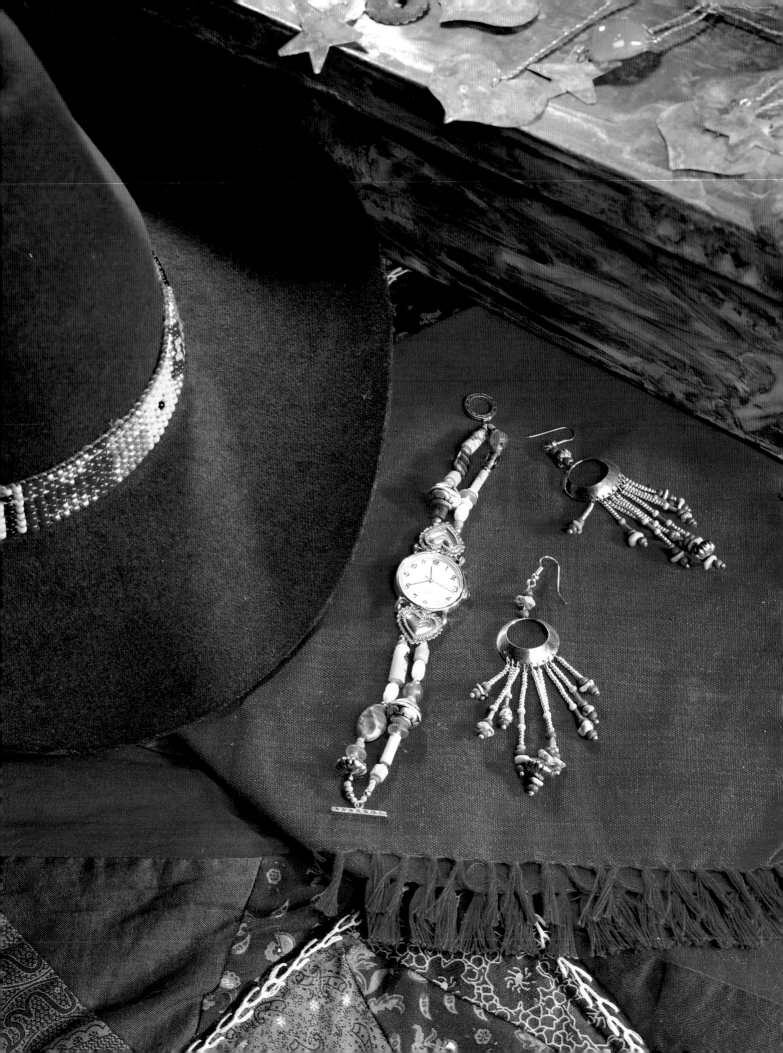

BEADED HATBAND

MATERIALS

6/0 seed beads:
- 126 opaque black
- 69 opaque aqua
- 24 opaque purple
- 54 opaque dark green
- 85 metallic gold
- 48 opaque red
- 61 opaque light blue
- 99 opaque maroon
- 41 opaque yellow
- 19 opaque orange
- 51 opaque royal blue
- 60 metallic copper
- 75 metallic silver

Four 10-mm royal blue flat donut wood beads
Two 12-mm dark red round wood beads
Two 10-mm natural round wood beads
Eight 40" lengths of assorted colored perle cotton thread
One 10-yard spool of #1 nylon thread
Beading needle
Beading loom

DIRECTIONS

1. Using perle cotton thread, warp the loom following the manufacturer's instructions. (The warp is the set of threads stretched lengthwise on a loom to form the vertical axis of a woven textile.)

2. Wind back 10" of the warp, following manufacturer's instructions, and begin beading according to the pattern on page 23. Bead entire pattern.

3. Remove the beaded piece from the loom, being careful not to cut any of the warp.

4. Finish the ends of the beaded piece with simple knots and beads; see diagram.

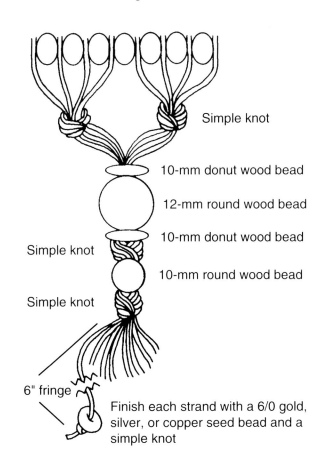

Simple knot

10-mm donut wood bead

12-mm round wood bead

10-mm donut wood bead

Simple knot

10-mm round wood bead

Simple knot

6" fringe

Finish each strand with a 6/0 gold, silver, or copper seed bead and a simple knot

DIAGRAM

5. Tie the completed hatband onto a hat.

BEADED WATCHBAND

MATERIALS

Watch face with spring clips
Five-holed metal watchband finding compatible
 with size of the watch face surface
Bracelet clasp
#0 nylon thread
Beading needle
Assorted beads to bead a 12" length

DIRECTIONS

1. Thread beading needle with a 16" length of nylon.

2. Tie one bead onto the thread about 5" from the end.

3. Run the needle through the outer hole in the watch finding and pull until the bead meets the metal.

4. Thread enough beads onto the nylon to achieve a 3" length.

5. Run the needle through the hole in one end of the bracelet clasp. Run the needle back through half the beads on the strand.

6. Run the 5" end of nylon through the finding hole and back through the strand of beads until it meets the other end of the thread. Tie a tight square knot in the thread.

7. Glue the knot and then rethread the ends of the thread through the needle and bury the ends within the bead strand; see diagram. Clip any excess thread.

8. Repeat this procedure to make two beaded strands on each side of the watchband.

9. Secure the band to the watch face with the spring clips.

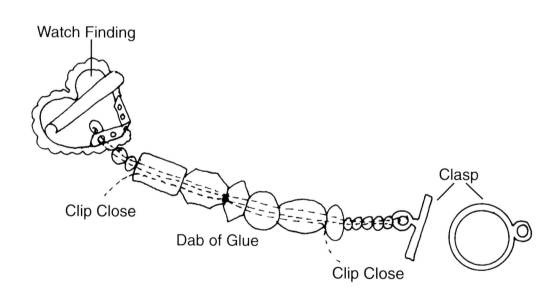

Watch Finding

Clip Close

Dab of Glue

Clip Close

Clasp

DIAGRAM

BEADED EARRINGS

MATERIALS

One pair of sterling silver earwires
Twenty .21-gauge silver headpins
One pair of 1¼" silver open disks with nine holes
250 metallic silver 11/0 seed beads
8 opaque purple 8/0 seed beads
16 opaque aqua 8/0 seed beads
Twenty-two 8-mm turquoise chips
42 opaque dark purple 6/0 seed beads
One 12-mm silver melon-shaped bead
14 iris topaz matte #2 bugle beads
Needle-nose pliers

DIRECTIONS

1. Slip beads onto the headpins, making two of A and four each of B, C, D, and E; see diagram.

2. Trim each headpin to ⅜" above the last bead.

3. Using needle-nose pliers, make a loop in the top of each headpin, slipping it through the appropriate hole on the sliver disk; see diagram. Close each loop carefully with the pliers.

4. Assemble the remainder of the earring according to the diagram.

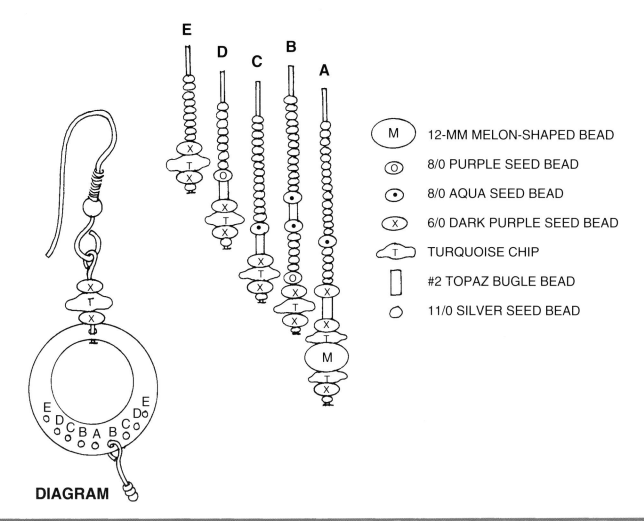

E D C B A

(M) 12-MM MELON-SHAPED BEAD

⊚ 8/0 PURPLE SEED BEAD

⊙ 8/0 AQUA SEED BEAD

⊗ 6/0 DARK PURPLE SEED BEAD

T TURQUOISE CHIP

▯ #2 TOPAZ BUGLE BEAD

○ 11/0 SILVER SEED BEAD

DIAGRAM

When I was just
 a kid back home,
me and my brothers
 used to roam,
o'er hill and
 grassy glade.

With shouts of glee,
 we'd race to see
what natures
 whims had made.

On our ponies race
 from place to place
exploring everything.
 And to our minds
the things we'd find
 would thoughts
of grandeur bring.

We'd conjure up stories
 of long past glories,
such over active minds.
 There were Indian tales
and ghostly wails,
 heroes of every kind.

 —Don Kennington

FOR THE
BUNKHOUSE

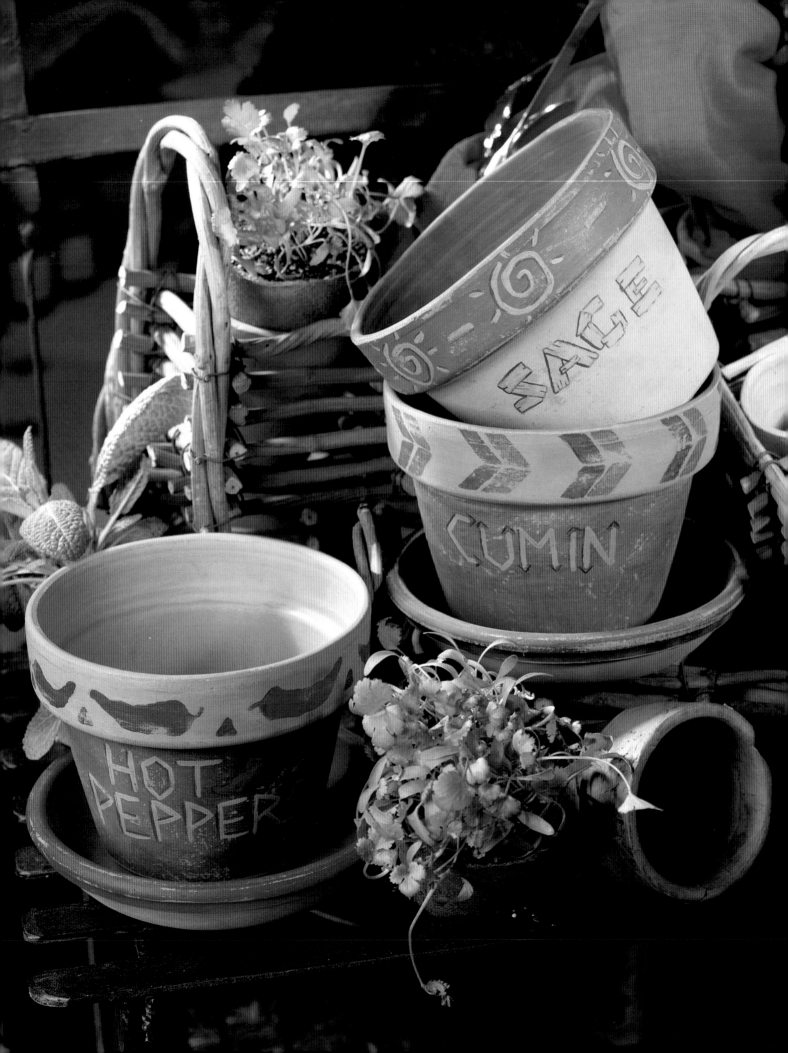

DESERT FLOWERPOTS

Potted plants dress up the bunkhouse, especially with good things like herbs and chilies in 'em. Their Mexican neighbors gave old-time Arizonans a taste for hot peppers and traditional colors. The style of these pots reflects that tasty mix of cultures. Use the alphabets provided to label your set any way you like, amigos!

MATERIALS (for the pots shown)

Three terra cotta pots, 6" in diameter with
 matching saucers
Pencil and tracing paper
Graphite paper
Manila folder
Craft knife
Acrylic paints: forest green, yellow-brown, red, blue,
 dark brown, rust, and tan
Stencil brushes
Small sponges

DIRECTIONS

1. For an old-time effect, use dry brush or sponge for painting and stenciling so that the terra cotta shows through. Paint pot necks inside and out as follows: yellow-brown for hot-pepper pot, blue for sage pot and tan for cumin pot. Paint pots as follows: green for hot-pepper pot, tan for sage pot and rust for cumin pot. Paint saucers as follows: green, rust and yellow-brown. Allow pots and saucers to dry.

2. Using copy machine, copy alphabet and sun pattern. Using graphite paper, transfer letters to pots. Repeat sun pattern around neck of sage pot.

3. Trace stencil patterns for peppers and chevrons. Transfer to manila folder. Cut out, using craft knife.

4. Stencil peppers in red with green tops and dark brown triangles. Stencil chevrons in green and rust. Paint suns in yellow with dark brown accents. Paint lettering as desired; see photo.

Did You Know? The smallest peppers are the hottest. And the seeds are hottest of all!

SUN PATTERN

CHEVRON PATTERN

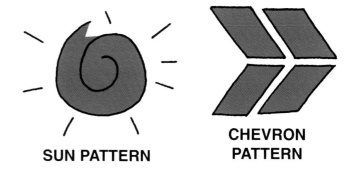

ALPHABET PATTERN

PEPPERS PATTERN

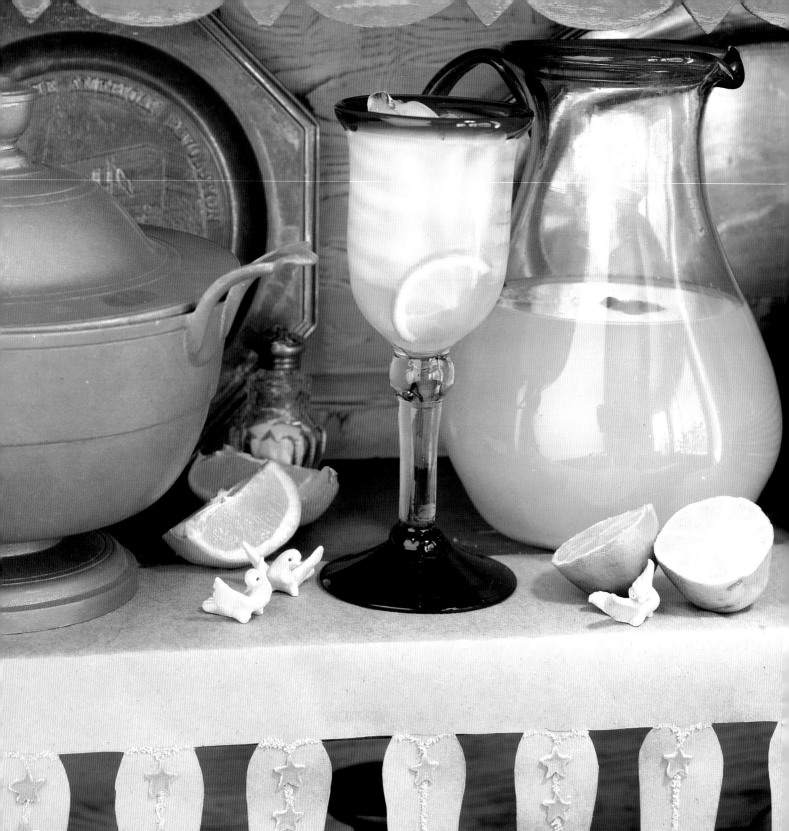

LI'L BOOTS SHELF LINER

MATERIALS

Pencil and tracing paper
Lightweight cardboard
Glue
Peel of one lemon or orange
Grater

DIRECTIONS

1. Trace cowboy boot pattern onto lightweight cardboard, repeating as necessary to achieve desired length. Cut out. Trace star pattern onto lemon or orange peel. Cut out enough stars to decorate each boot; let dry.

2. Grate remaining peel; let dry.

3. Using glue, draw design onto each cowboy boot. Sprinkle dried peel on wet glue; let stand for a short time and then shake off excess peel. Glue dried stars to each boot as desired; see photo.

4. Fold shelf liner as indicated on pattern. Place on shelf.

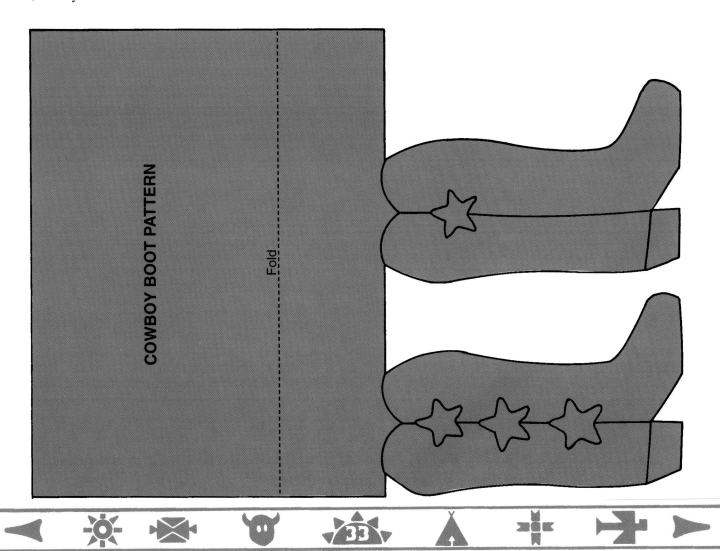

COWBOY BOOT PATTERN

Fold

A Cowboy's Christmas Prayer

I ain't much good at prayin', and You may not know me,
I ain't much seen in churches where they preach Thy Holy word,
But You may have observed me me out here on the lonely plains,
A-lookin' after cattle, feelin' thankful when it rains,

Admirin' Thy great handiwork, the miracle of grass,
Aware of Thy kind spirit in the way it comes to pass
That hired men on horseback and the livestock that we tend
Can look up at the stars at night and know we've got a Friend.

Don't let no hearts
bitter, Lord; don't l
no child be cold.
Make easy beds for
them that's sick, and
them that's weak
and old.
Let kindness bless
the trail we ride,
no matter what
we're after,
And sorter keep us
on your side, in tears
as well as laughter.

So here's ol' Christmas comin' on, remindin' us again
Of Him whose coming brought good will into the hearts of men.
A cowboy ain't no preacher, Lord, but if you'll hear my prayer,
I'll ask as good as we have got for all men everywhere.

I've seen o
starvin', ar
no happy
Please do
one hungr
Thy
nig
No
wo
on
I'll
to
chu

I'm just a sinful cowpoke, Lord—ain't got no business prayin
But still I hope You'll ketch a word or two of what I'm sayin
We speak of Merry Christmas, Lord—I reckon You'll agree
There ain't no Merry Christmas for nobody that ain't free.
So one thing more I'll ask of You, Lord: just help us what Yo
To save some seeds of freedom for the future sons of man!

— O.S. Omar Barker

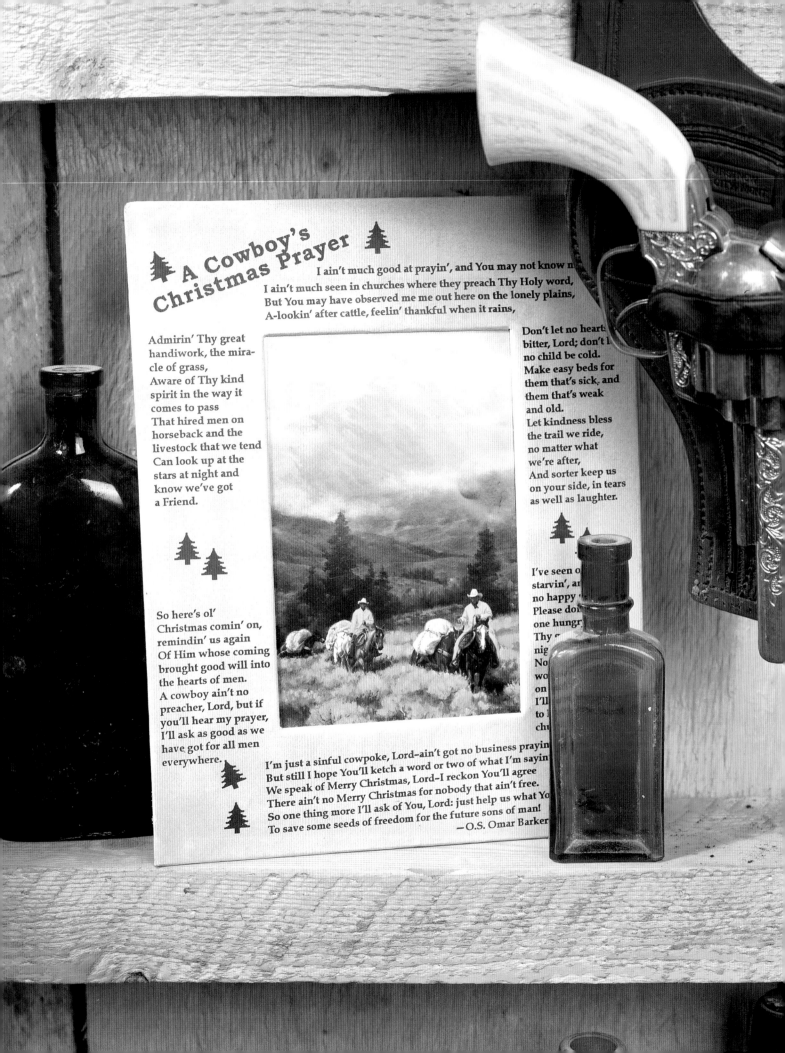

PAPER POETRY FRAME

MATERIALS

Three 8" x 10" sheet of lightweight cardboard
Three 10" x 12" sheets of heavy paper
Pencil and tracing paper
Light brown acrylic paint
Paintbrush
Craft knife
Spray adhesive
Hot glue gun and glue sticks
Copy machine

DIRECTIONS

1. Make frame stand pattern. From one sheet of cardboard, draw one stand the same as pattern and one on heavy paper about ¹⁄₁₆" smaller than pattern. Also on heavy paper, draw one stand with ½" added to side and top edges and 1" added to bottom edge. Cut out stands. From one 8" x 10" sheet of cardboard, cut a 4" x 6" window.

2. Using copy machine, copy poem onto one sheet of heavy paper. Using cardboard with window, spray with adhesive. Center poem over windowed cardboard; press in place. Clip edges and fold to back side; glue. Cut an "X" in opening of window; see Diagram A. Fold to back side; trim and glue. Repeat with remaining sheet of cardboard.

3. With wrong sides facing, glue front of frame to back, leaving top open to insert picture.

4. To make frame stand, apply glue to one surface of cardboard. Aligning side and top edges, glue to enlarged paper stand. Cut paper edges; see Diagram B. Fold excess paper to back and glue. Center and glue remaining paper stand to back of covered stand. Score stand according to pattern. Glue stand to frame back with stand top about ½" below top edge of frame.

5. Mix a few drops of paint with about ¼ cup of water. Wash entire frame. Let dry.

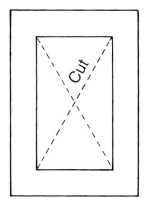

DIAGRAM A

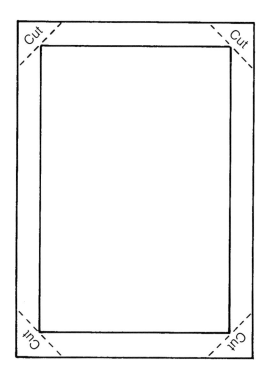

DIAGRAM B

A Cowboy's Christmas Prayer

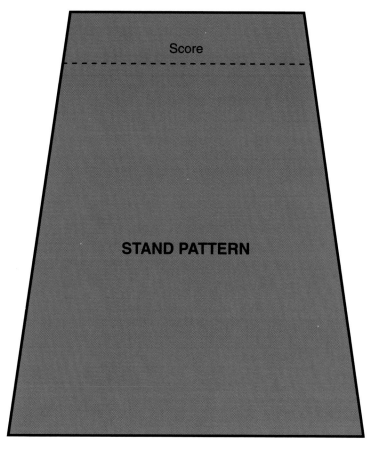

Score

STAND PATTERN

I ain't much good at prayin', and You may not know me, Lord...
I ain't much seen in churches where they preach Thy Holy word,
But You may have observed me out here on the lonely plains,
A-lookin' after cattle, feelin' thankful when it rains,

Admirin' Thy great handiwork, the miracle of grass,
Aware of Thy kind spirit in the way it comes to pass
That hired men on horseback and the livestock that we tend
Can look up at the stars at night and know we've got a Friend.

So here's ol' Christmas comin' on, remindin' us again
Of Him whose coming brought good will into the hearts of men.
A cowboy ain't no preacher, Lord, but if you'll hear my prayer,
I'll ask as good as we have got for all men everywhere.

Don't let no hearts be bitter, Lord; don't let no child be cold.
Make easy beds for them that's sick, and them that's weak and old.
Let kindness bless the trail we ride, no matter what we're after,
And sorter keep us on your side, in tears as well as laughter.

I've seen old cows a-starvin', and it ain't no happy sight:
Please don't leave no one hungry, Lord, on Thy good Christmas night–
No man, no child, no woman, and no critter on four feet–
I'll aim to do my best to help You find 'em chuck to eat.

I'm just a sinful cowpoke, Lord–ain't got no business prayin'...
But still I hope You'll ketch a word or two of what I'm sayin':
We speak of Merry Christmas, Lord–I reckon You'll agree
There ain't no Merry Christmas for nobody that ain't free.
So one thing more I'll ask of You, Lord: just help us what You can
To save some seeds of freedom for the future sons of man!
 —O.S. Omar Barker

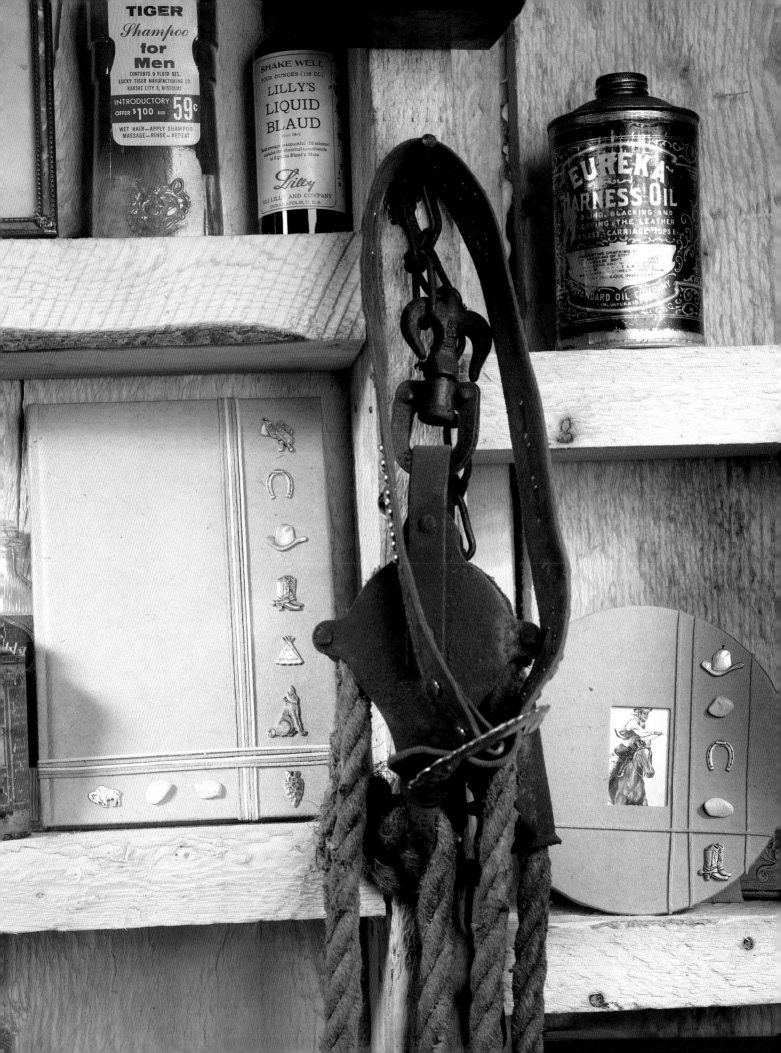

BEADED PAPER FRAME

MATERIALS

Compass
Ruler
Pencil and tracing paper
11" x 14" piece of cardboard
Large sheet of brown paper
Craft knife
Hot glue gun and glue
32" length of suede leather cord
Assorted flat Western-style decorations
Two small turquoise or other decorative stones

DIRECTIONS

1. Using compass, draw two 6"-diameter circles on cardboard. Draw two 7"-diameter circles on brown paper. In center of one cardboard circle, draw photo window in desired size; cut out window. Cut out circles.

2. Apply glue to one surface of plain cardboard circle. Center on one brown paper circle and press in place. Repeat with remaining circles. Clip edges of brown paper circles about ½" apart; see Diagram A. Fold excess paper to back and glue.

3. Cut paper in photo window of covered circle; see Diagram B. Fold excess paper to back and glue.

4. Cut suede cord into 8" lengths. Glue to frame front as desired, wrapping and gluing ends to back; see photo. Glue decorations and turquoise to frame front as desired.

5. Leaving 2" of edges unglued for insertion of photo and with wrong sides together, glue frame front to frame back by beading glue along edges.

6. Trace frame stand pattern on page 36. Draw one stand on cardboard the same as pattern and one on brown paper about ⅟₁₆" smaller than pattern. Also on brown paper, draw one stand with ½" added to side and top edges and 1" added to bottom edge. Cut out stands.

7. Apply glue to one surface of cardboard stand. Aligning side and top edges, glue to enlarged paper stand. Cut paper edges; see Diagram C. Fold excess paper to back and glue. Center and glue remaining brown paper stand to back of covered stand. Score stand according to pattern.

8. Making sure photo window is straight, glue stand to frame back with stand top about 1⅜" below top edge of frame.

DIAGRAM A **DIAGRAM B** **DIAGRAM C**

To keep track of livestock, daily activities, and thoughts, or to dash off a sketch or two, there's nothing like a journal. With its beautifully decorated cover, this one makes a unique gift (and you'll want one to keep, too).

MATERIALS

Purchased journal
Heavy brown craft paper
Spray adhesive
Assorted Western-style flat charms
Flat concho
Two small pieces of turquoise or other polished stone
One package each of suede leather cord in three
 assorted colors
Hot glue gun and glue sticks

DIRECTIONS

1. Open journal out flat with front and back covers up. Place on craft paper. Lightly trace outline of journal, adding 2" all around. Cut out.

2. Using spray adhesive, glue craft paper cover first to front cover, smoothing firmly. Press paper into fold along spine; then glue paper to spine. Repeat on back of journal.

3. Clip edges of paper cover; see diagram. Fold front cover edges to inside; glue. Repeat with back cover edges.

4. Cut suede cord into six 10" lengths and five 15" lengths, using each color. Arrange 10" lengths side by side vertically on front cover 1½" from outside edge; see photo. Handling ends as one, fold to inside of cover; glue. Use small beads of glue under cord to secure to cover. Fold and glue opposite ends.

5. Carefully open journal out flat. Arrange 15" lengths horizontally across front cover, spine and back cover 1" above bottom edge; see photo. Glue as in Step 4, making sure book will close without stretching or breaking cords.

6. Glue charms and turquoise to cover as desired; see photo.

7. Cut eight to ten lengths of leather cord, using all colors. Thread through concho and knot. Trim ends to desired length. Glue concho to book cover.

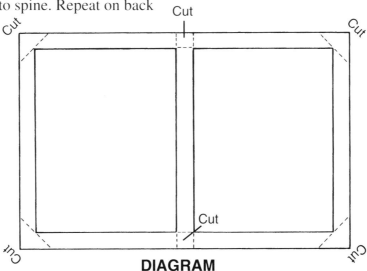

DIAGRAM

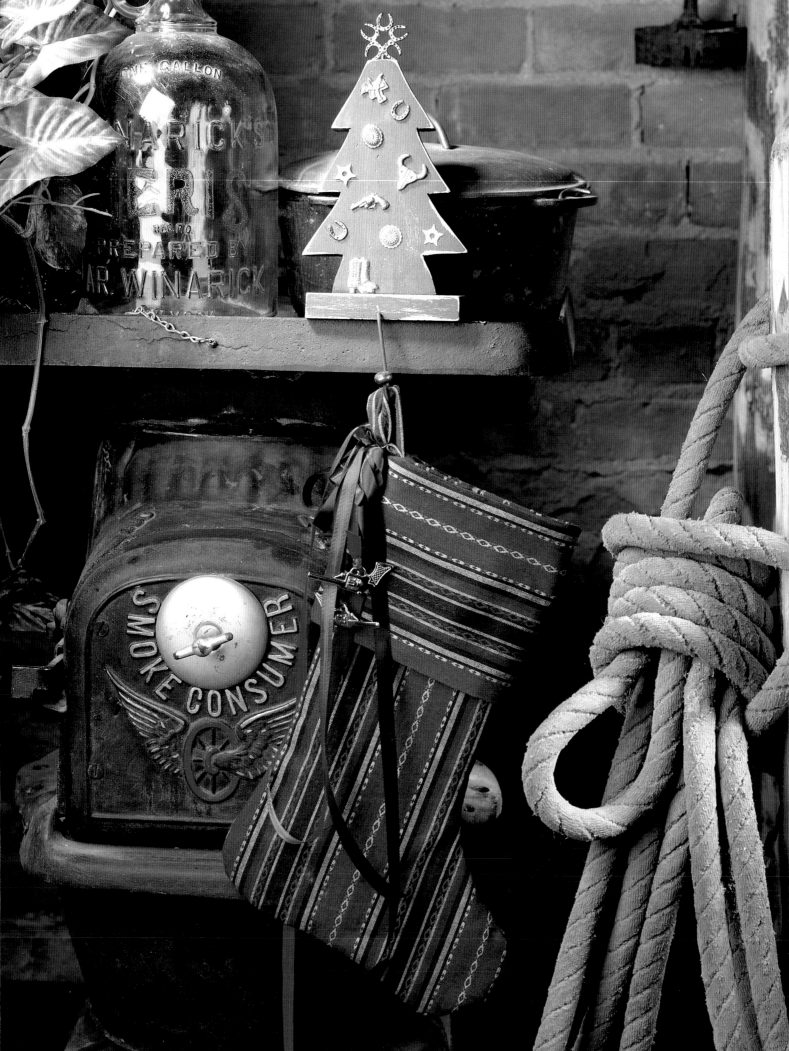

XMAS TREE STOCKING HOLDER

MATERIALS

Pencil and tracing paper
Graphite paper
10" x 12" x ¾" piece of wood
Scroll saw
Acrylic paint: dark green and brown
Paintbrush
Seven small metal horseshoe charms
Seven other assorted charms
6" of ⅛" wire
One ½" wooden bead with a ⅛" hole
Soldering iron and resin core solder
Medium sandpaper
Hot glue gun and glue sticks
Drill with ¼" bit and ⅛" drill bit
Two ½" wood screws

DIRECTIONS

1. Trace Christmas tree pattern. Using graphite paper, transfer pattern to wood. Cut out with scroll saw. Also, cut one 3" x 5" piece of wood for base.

2. Paint front of Christmas tree dark green. Paint base brown. Allow to dry. Lightly sand edges for antique effect.

3. To make horseshoe star, arrange five horseshoe charms in a circle with curved edges touching; solder together; see photo. Cut a 1" length of wire. Solder wire to bottom of horseshoe star.

4. Hot-glue remaining charms to Christmas tree front as desired; see photo. Bend remaining length of wire to form a hook with a 1" tail; see diagram. Hot-glue bead to hooked end of wire; set aside.

5. Center and hot-glue Christmas tree figure to base.

6. Using ¼" bit, drill two holes through center bottom of base, stopping at Christmas tree figure. Insert one screw in each hole and tighten into cactus figures.

7. Using ⅛" bit, drill one hole, 1" deep, at center front edge of base. Drill another hole, ½" deep, at center top edge of tree. Insert horseshoe star in hole in tree; secure with hot glue. Insert hook in hole in base; secure with hot glue.

DIAGRAM

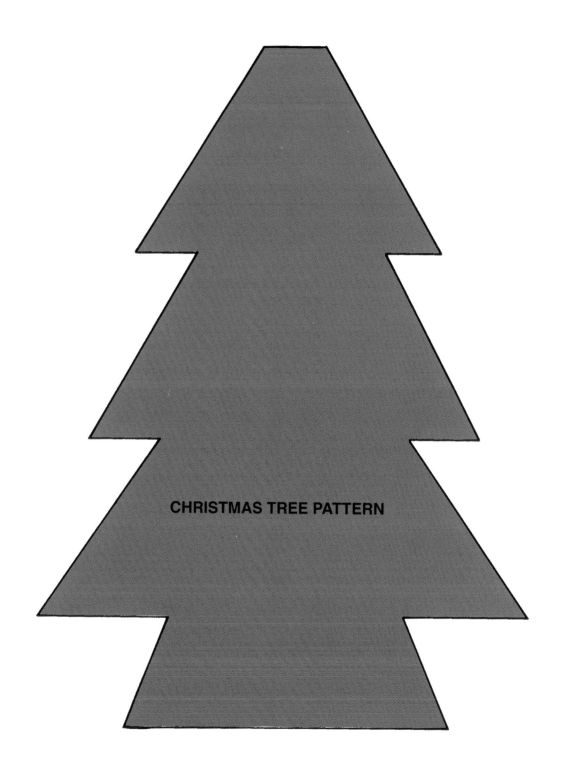

CHRISTMAS TREE PATTERN

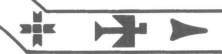

DARN GOOD DOORSTOP

MATERIALS

12" square of 1" pine wood
22 ½" length of ¼" dowel
One horseshoe
Copper spray paint
Black acrylic paint
Medium sandpaper
Wood glue
Three finishing nails
Scroll saw or jig saw
Drill with ¼" drill bit

DIRECTIONS

1. Make cowboy pattern. From wood, cut one cowboy and two ¼" x 6 ½" strips. From dowel, cut three 7½" lengths.

2. To make fence, drill three holes in each wood strip 2" apart, starting 1½" from top. Slide dowels through holes. Glue fence to back of cowboy. Nail cowboy and fence to horseshoe through horseshoe holes.

3. Spray-paint entire doorstop with copper. Let dry. Wash entire piece with black paint. Wipe off excess paint. Use sandpaper to stress edges.

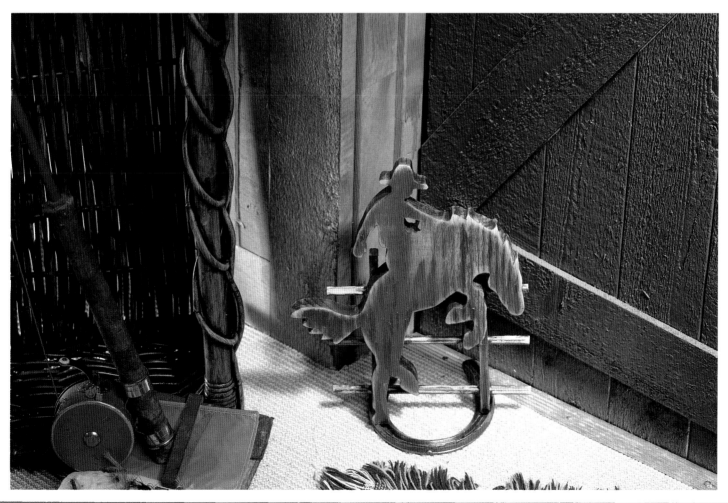

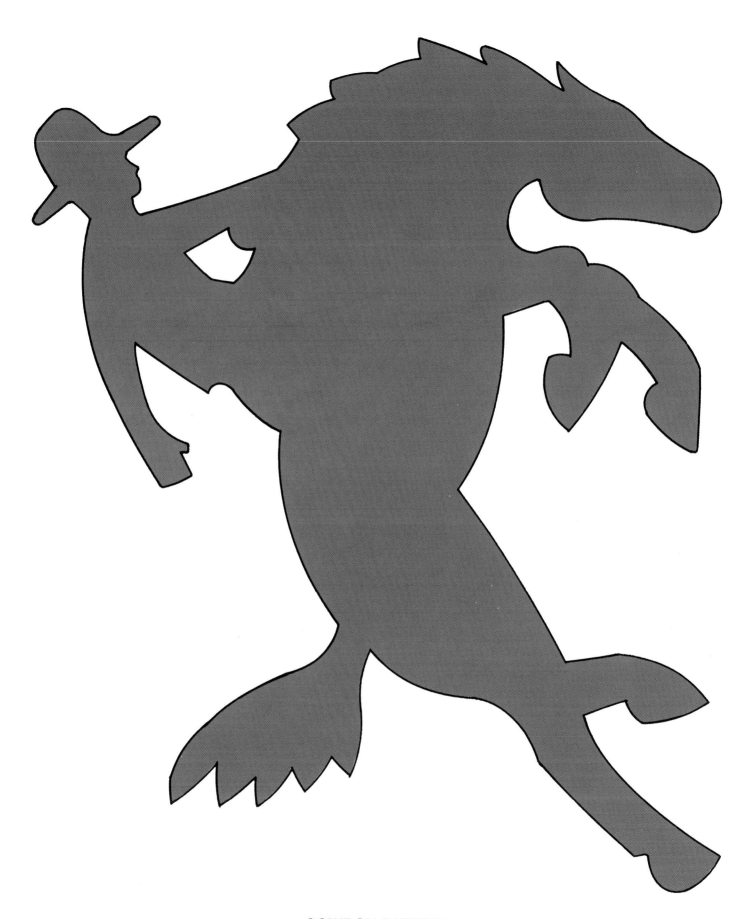

COWBOY PATTERN

44

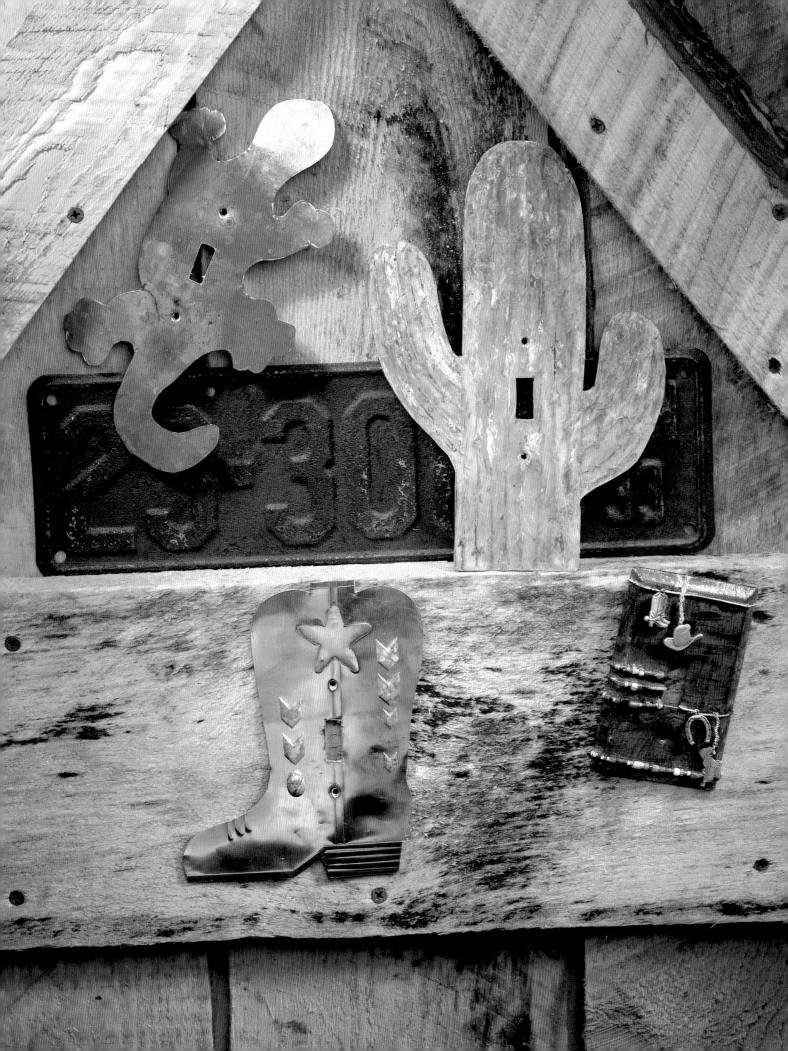

Boot Light Switch
MATERIALS

Sheet of 36-gauge tooling copper
Sheet of lightweight cardboard
Ballpoint pen
Sturdy scissors
Assorted plastic charms
Pencil and tracing paper
Graphite paper
Glue
Hammer and nail

DIRECTIONS

1. Make cowboy boot pattern. Using ballpoint pen, trace cowboy boot outline and interior onto copper. Using scissors, cut out cowboy boot along outline and hole for switch. With hammer and nail, punch holes in cowboy boot for screws. Cut one cowboy boot from lightweight cardboard, cutting holes for switch and punching holes for screws.

2. Glue charms to boot as desired; see photo.

3. Glue cardboard to back of copper cowboy boot.

Cactus Light Switch
MATERIALS

Sheet of 36-gauge tooling copper
Sheet of lightweight cardboard
Ballpoint pen
Sturdy scissors
Brush-on metal patina
Paintbrush
Steel wool
Pencil and tracing paper
Graphite paper
Glue
Hammer and nail

DIRECTIONS

1. Make cactus pattern. Using ballpoint pen, trace cactus outline and interior onto copper. Using scissors, cut out cactus along outline and hole for switch. With hammer and nail, punch holes in cactus for screws. Cut one cactus from lightweight cardboard, cutting holes for switch and punching holes for screws.

2. Brush several coats of metal patina on cactus, following manufacturer's instructions. Allow to dry between applications.

3. Glue cardboard to back of copper cactus.

Lizard Light Switch
MATERIALS

Sheet of 36-gauge tooling copper
Sheet of lightweight cardboard
Ballpoint pen
Sturdy scissors
Brush-on metal patina
Paintbrush
Steel wool
Pencil and tracing paper
Graphite paper
Glue
Hammer and nail

DIRECTIONS

1. Make lizard pattern. Using ballpoint pen, trace lizard outline and interior onto copper. Using scissors, cut out lizard along outline and hole for switch. With hammer and nail, punch holes in lizard for screws. Cut one lizard from lightweight cardboard, cutting holes for switch and punching holes for screws.

2. Brush several coats of metal patina on lizard, following manufacturer's instructions. Allow to dry between applications.

3. Glue cardboard to back of copper lizard.

Beaded Light Switch
MATERIALS

One purchased brass light switch plate
Wire cutters
Soldering iron and resin core solder
Steel wool
Brown acrylic paint
Paintbrush
Assorted beads
Wire
Four assorted cowboy charms

DIRECTIONS

1. Using steel wool, scratch entire surface of light switch plate. Dry-paint surface of light switch plate with brown paint, using uneven strokes.

2. Solder charms and beads to lengths of wire as desired. Wrap adorned wire lengths to back side of light switch plate and solder.

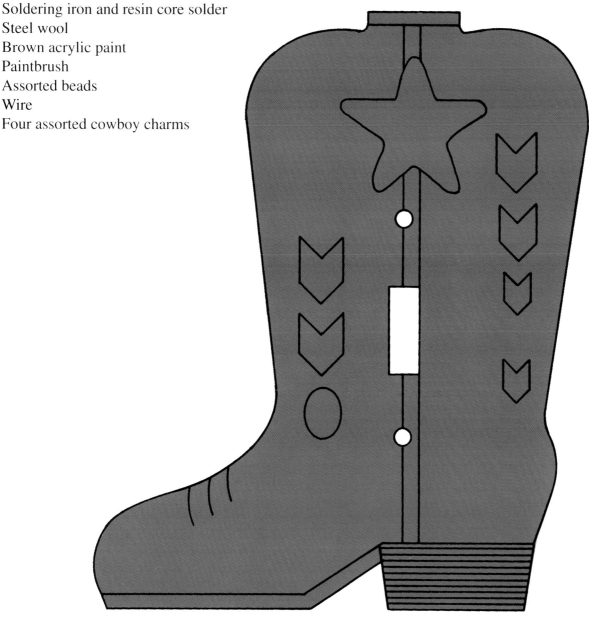

COWBOY BOOT PATTERN

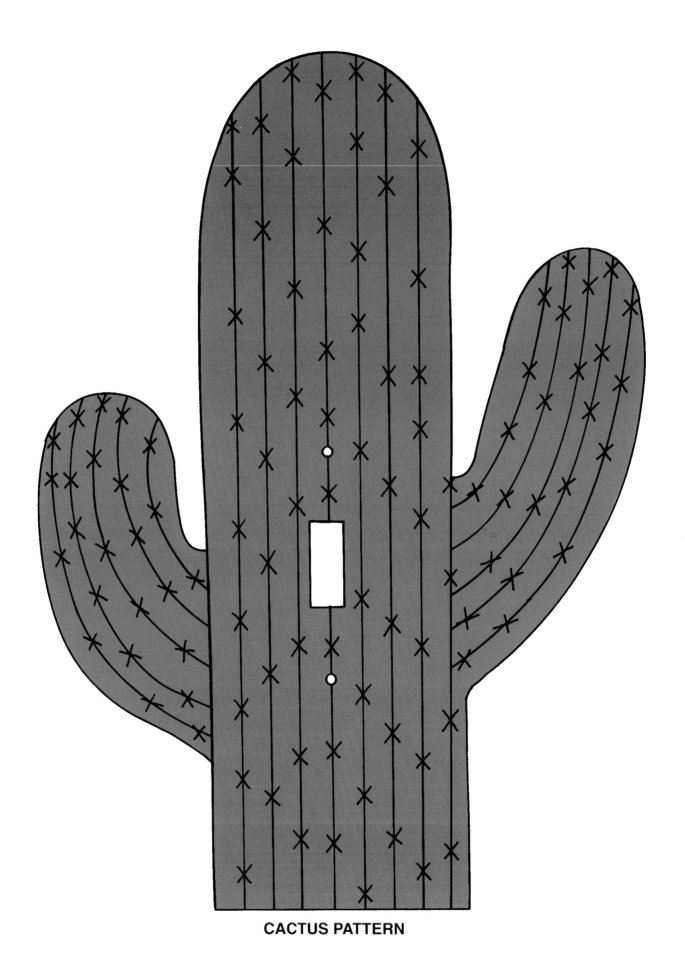

CACTUS PATTERN

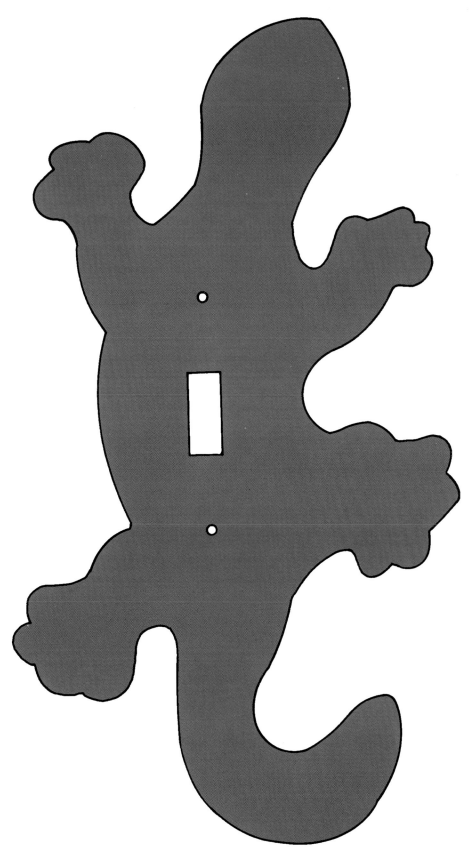

LIZARD PATTERN

49

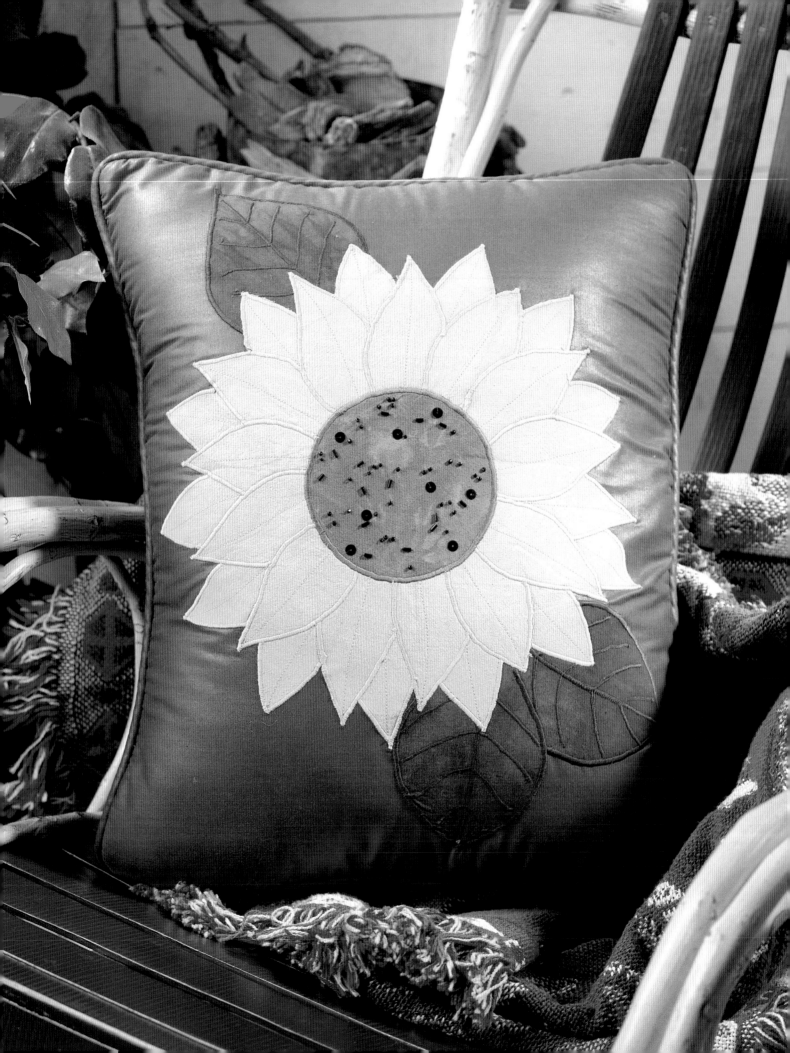

SUNFLOWER PILLOW

Bring the brightness of a prairie springtime indoors with this bold pillow. The design would be just right for a wall hanging, too; trim the bottom edge with fringe.

MATERIALS

1¾ yards of brown fabric
½ yard of bright yellow fabric
¼ yard of dark green fabric
¼ yard of tan fabric
2 yards of ½"-wide cording
19" x 20" piece of fusible webbing
Iron
16" x 20" piece of tear-away
Sewing machine with embroidery foot
Yellow thread
Dark green thread
Tan thread
Assorted black seed beads, black flat round sequins, black bugle beads
16" x 20" piece of fleece
Polyester stuffing

DIRECTIONS
All seams are ¼".

1. From brown fabric, cut two 16" x 20" pieces for pillow top and back. Also cut 2"-wide bias strips, piecing as needed to equal 2 yards. Make 2 yards of corded piping; set aside.

2. Trace flower patterns. Transfer to paper side of fusible webbing, drawing 14 of Petal B, 13 of Petal A, three leaves and one flower center, with about ¼" between each. Cut out, keeping space intact; do not remove paper.

3. Fuse petals to yellow fabric, leaves to dark green fabric and flower center to tan fabric. Cut out flower pieces. Remove paper. Place one brown fabric piece on ironing board. Arrange flower pieces in a circle on fabric as follows: large petals first, small petals next, flower center; see photo. Slide leaves under large petals where desired. Fuse flower pieces to pillow top.

4. Place shiny side of tear-away against wrong side of pillow top. Iron.

5. Machine satin-stitch appliqués. Stitch around leaves with dark green thread. Also stitch veins on leaves according to pattern. Stitch around petals with yellow thread. Also with yellow thread, machine stitch along centerline of each petal. Stitch around flower center with tan thread.

6. To remove tear-away, make a small scissor cut in portion of tear-away backing appliqués. Lift and tear.

7. Sew beads to flower center as desired; see photo.

8. Center fleece on wrong side of pillow top. Baste. With right sides facing, sew piping to pillow top, rounding corners. With right sides facing, sew pillow back to pillow top along stitching line of piping, leaving an opening. Trim fleece from seam allowance. Turn.

9. Stuff pillow firmly. Slipstitch opening closed.

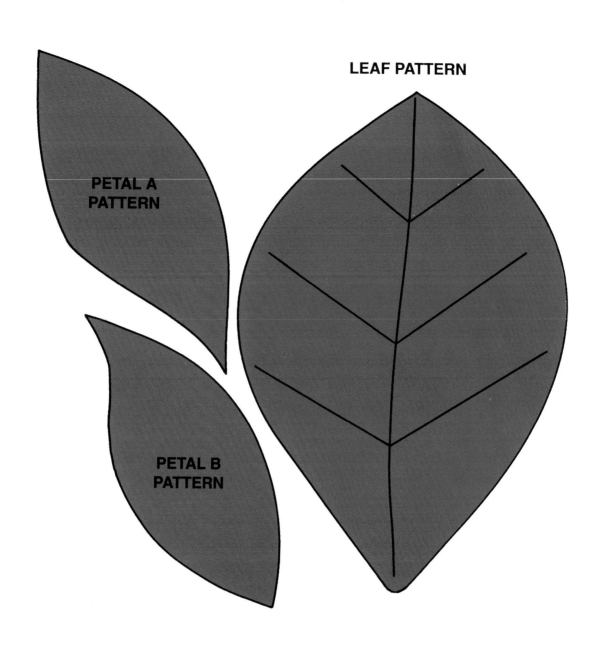

LEAF PATTERN

PETAL A PATTERN

PETAL B PATTERN

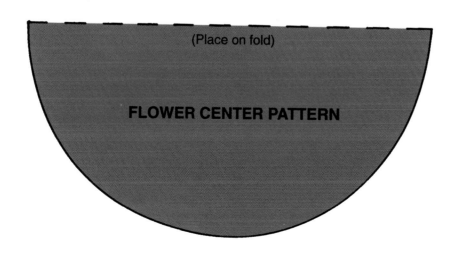

(Place on fold)

FLOWER CENTER PATTERN

52

HANG 'EM UP COAT RACK

MATERIALS

Seven horseshoes
Silver spray paint
Black acrylic paint
Thin silver wire
Beads and rocks: assorted sizes, shapes, and colors
Welder

DIRECTIONS

1. Weld four horseshoes together in a row. Weld one edge of another horseshoe to seam between two horseshoes in row, open end up. Repeat two more times with remaining horseshoes; see photo. (Note: Using a professional welder is recommended.)

2. Spray-paint horseshoes silver. Let dry. Wash with black paint. Wipe off excess paint for an antique look.

3. Using wire, string beads and rocks as desired. Make four beaded lengths. Tie lengths around center of each horseshoe in row; see photo.

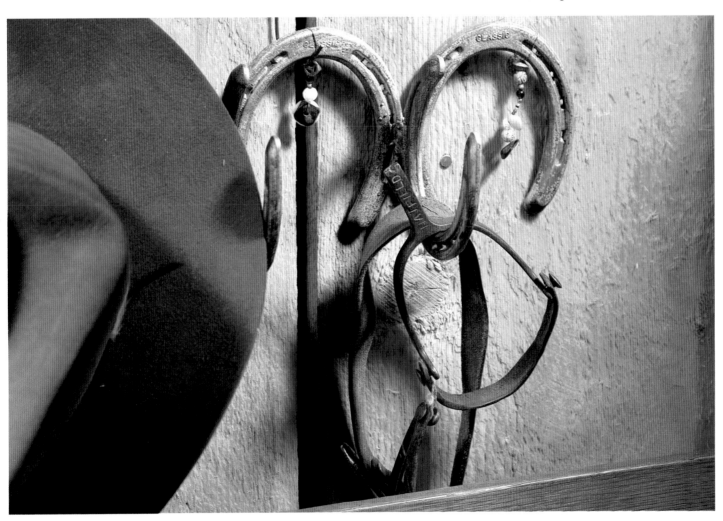

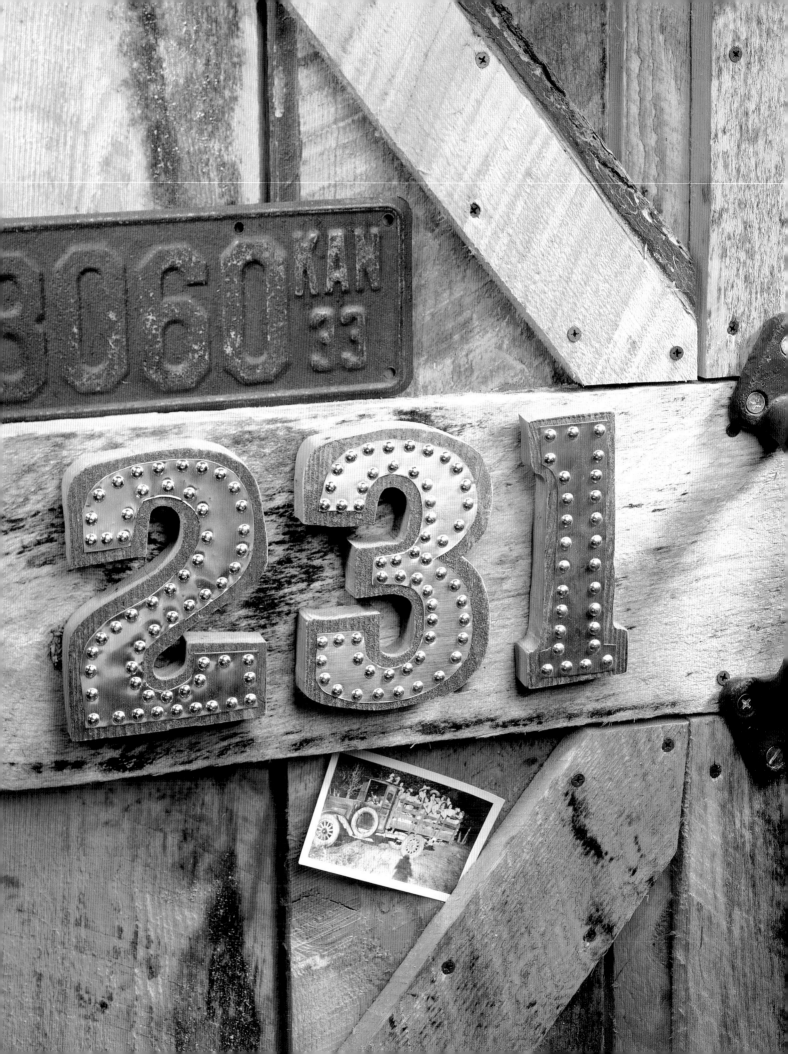

RANCH NUMBERS

These sturdy numbers will add a handsome touch to any home, whether cabin or castle. With the help of that newfangled convenience, the copy machine, make 'em any size you like. This is a wonderful way to use up interesting old scraps of wood, too.

MATERIALS

Copy machine
¾"-thick piece of used wood large enough
 for desired numbers
Jigsaw
Wood stain in desired color
Sheet of tooling brass or copper
Ballpoint pen
Sturdy scissors
Round-headed brass tacks
Hammer

DIRECTIONS

1. Enlarge numbers needed to desired size. Cut out along outside outline.

2. Trace outside outline of each number onto wood. Cut out. Stain both sides. Allow to dry.

3. Place paper numbers on brass or copper. Using ballpoint pen and pressing firmly, trace inside outline of each number. Cut out.

4. Center metal numbers on right side of wood numbers. Hammer tacks through metal into wood along outline of metal numbers.

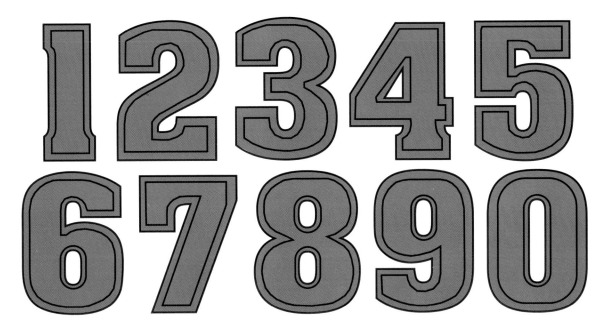

RANCH NUMBER PATTERNS

BANDANNA
WINDOW VALANCE

MATERIALS

½ yard each of three different colors of fabric;
 matching thread
Permanent fabric markers

DIRECTIONS
All seams are ½".

1. From each color of fabric, cut two 18" squares.

2. On the right side of one square of each color, draw brands and designs with fabric marker.

3. With right sides facing and edges aligned, stitch same-color squares together, leaving a small opening. Turn. Whipstitch opening closed. Repeat with remaining squares.

4. Press all squares. Fold squares in half diagonally. Lay overlapping ends over curtain rod above window.

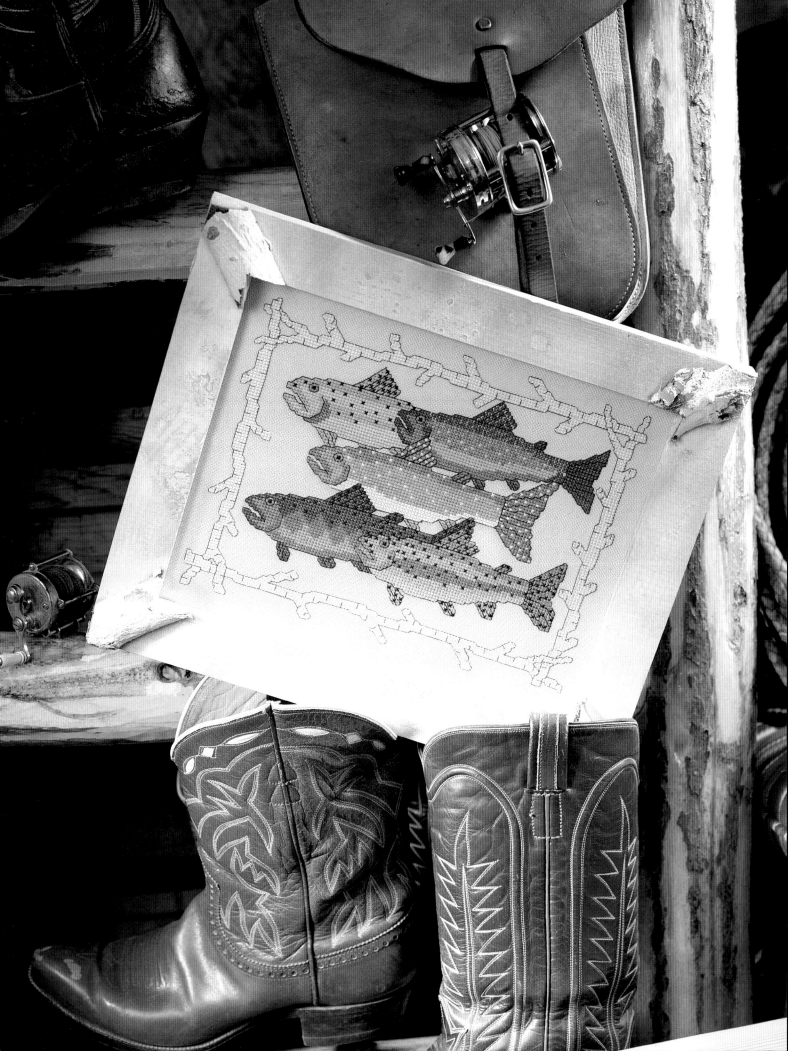

FISHES IN STITCHES

Stitched on Bone Lugana 25 over two threads, the finished design size is 10⅜" x 8⅛". The fabric was cut 17" x 15".

Fabrics	Design Sizes
Aida 11	11⅞" x 9¼"
Aida 14	9¼" x 7¼"
Aida 18	7¼" x 5⅝"
Hardanger 22	5⅞" x 4⅝"

Stitch Count: 130 x 102

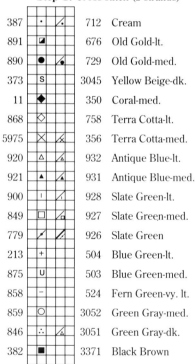

Anchor		DMC (used for sample)	
Step 1: Cross-stitch (2 strands)			
387	· /	712	Cream
891	◪	676	Old Gold-lt.
890	● /	729	Old Gold-med.
373	s	3045	Yellow Beige-dk.
11	◆	350	Coral-med.
868	◇	758	Terra Cotta-lt.
5975	✕ /	356	Terra Cotta-med.
920	△ /	932	Antique Blue-lt.
921	▲ /	931	Antique Blue-med.
900	ı /	928	Slate Green-lt.
849	□ /	927	Slate Green-med.
779	⁄ /	926	Slate Green
213	+	504	Blue Green-lt.
875	U	503	Blue Green-med.
858	−	524	Fern Green-vy. lt.
859	○	3052	Green Gray-med.
846	∴ /	3051	Green Gray-dk.
382	■	3371	Black Brown

Step 2: Backstitch (1 strand)

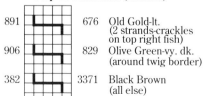

891	676	Old Gold-lt. (2 strands-crackles on top right fish)
906	829	Olive Green-vy. dk. (around twig border)
382	3371	Black Brown (all else)

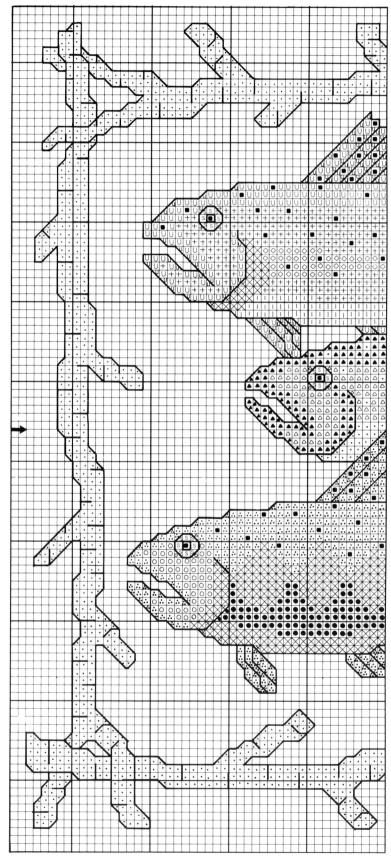

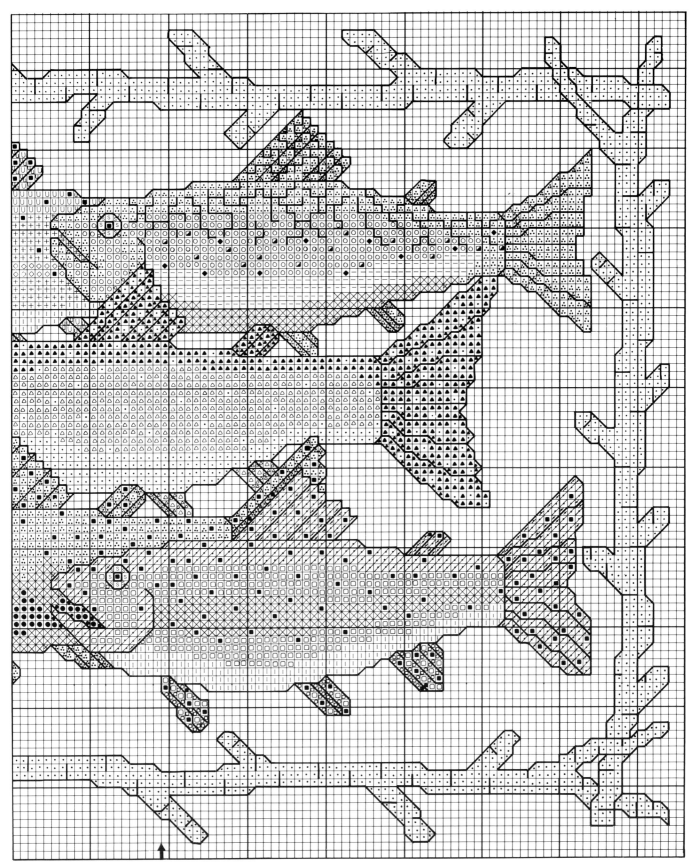

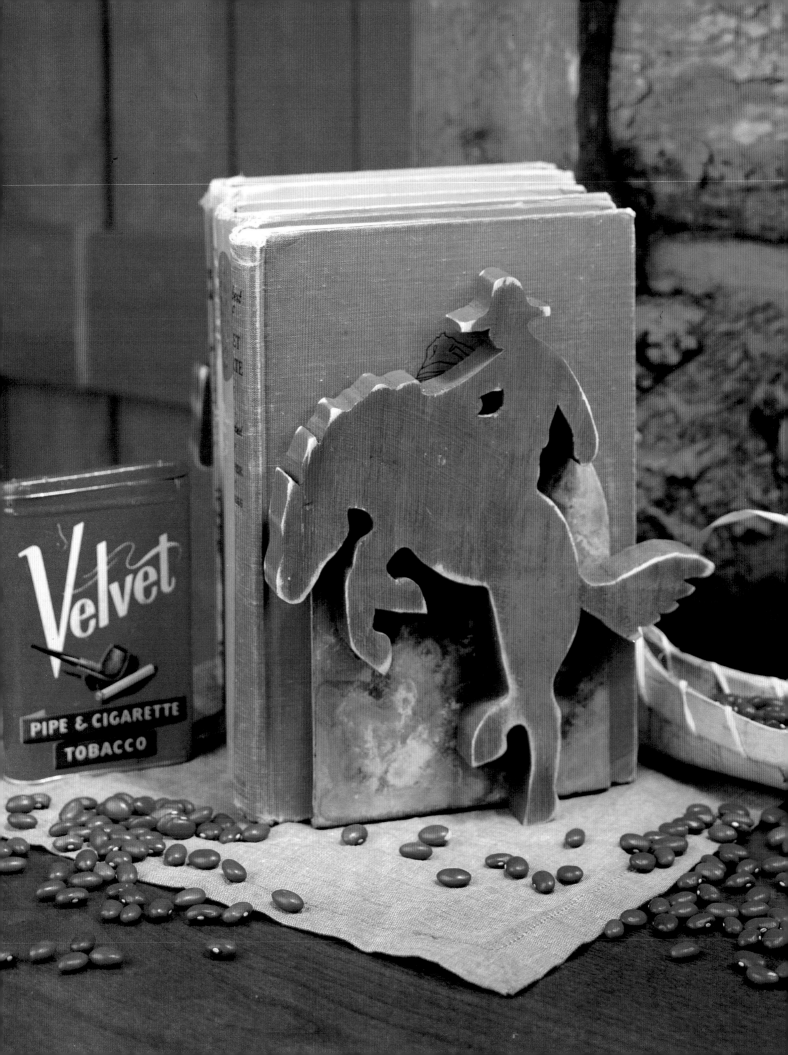

BUNKHOUSE BOOKENDS

Decorated with a rearing bronc and a brave buckaroo in a classic rodeo pose, these bookends look fancy but are easy to make. The cut-out figure by itself would also make a dandy decoration for a lamp base or a little cowpoke's toy box. Clip a friend's face from a photo and glue it on the cowboy to get a smile!

MATERIALS

Set of plain metal bookends
Sheet of 36-gauge tooling copper
Ballpoint pen
Sturdy scissors
Soldering iron
Brush-on metal patina
Steel wool
Pencil and tracing paper
Graphite paper
12" x 24" x ¾" piece of wood
Jigsaw
Brown acrylic paint
Paintbrush
Medium sandpaper
Hot glue gun and glue sticks
Drill with ¼" bit
Four ½" wood screws

DIRECTIONS

1. Using a ballpoint pen, trace outline of bookend's upright section onto copper for bookend liner. Trace second outline for bookend jacket; then add 1" all around. Using scissors, cut out liner and jacket.

2. Cut small slits from edges of jacket to outline. Place bookend face down on jacket outline and fold slit edges to back side. Center liner on back side over raw edges of jacket. Solder liner in place. Use steel wool to remove oils and fingerprints on jacket and liner. Repeat Steps 1–2 with second bookend.

3. Brush several coats of metal patina on jacket, following manufacturer's instructions; allow to dry between applications. Repeat with second bookend.

4. Trace bucking horse/cowboy pattern. Using graphite paper, transfer to wood, drawing two figures (reverse pattern for one figure, if desired). Cut out with scroll saw and keyhole saw. Paint both sides of figures walnut brown. Allow to dry. Lightly sand edges for antique effect.

5. Center and hot-glue one figure to jacket side of each bookend so that each horse's lower hind foot is flush with bottom edge of bookend; see photo.

6. Drill two holes through each bookend from back side, stopping at wood figures. Insert one screw in each hole and tighten into wood figures.

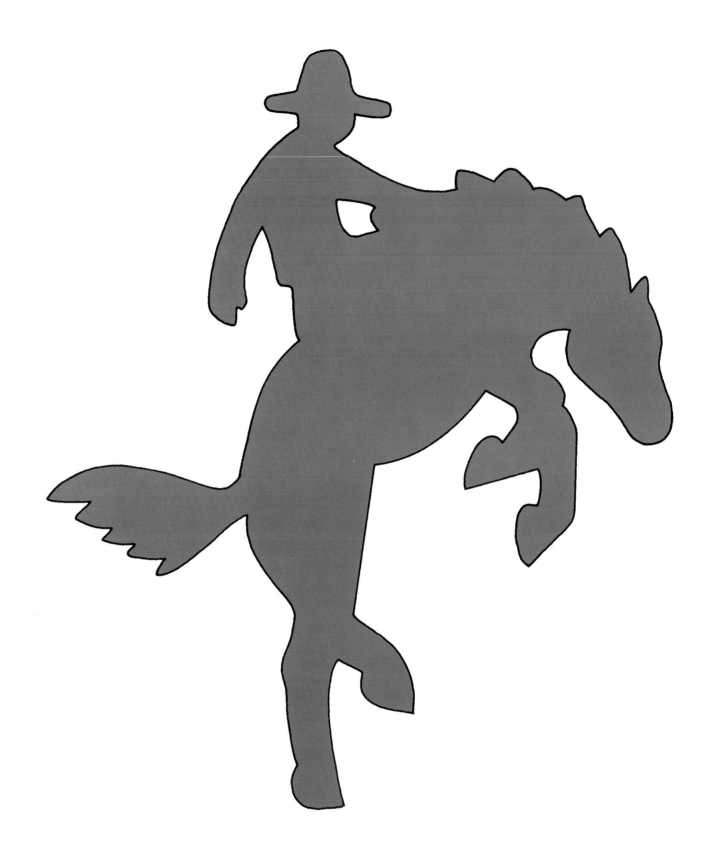

BUCKING HORSE/COWBOY PATTERN

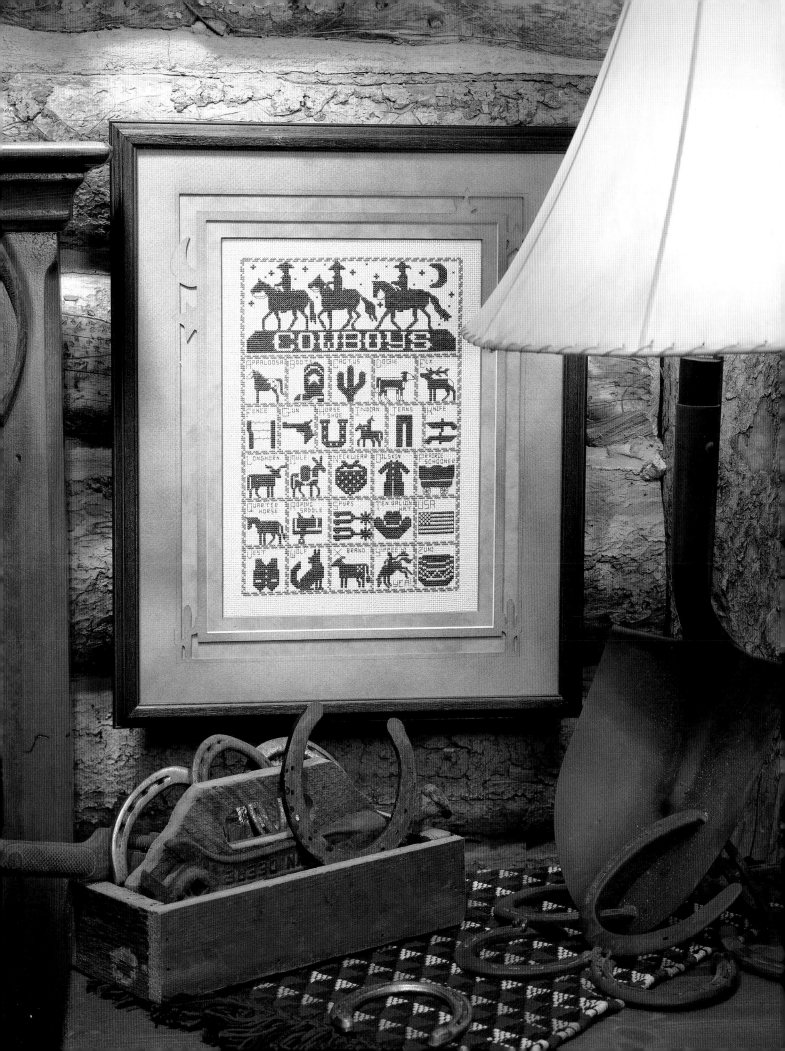

CROSS-STITCH SAMPLER

Stitched on Rustic 14 over one
thread, the finished design size
is 8¾" x 12⅛". The fabric was
cut 15" x 19".

Fabrics	Design Sizes
Aida 11	11⅛" x 15½"
Aida 14	8¾" x 12⅛"
Aida 18	6 3/4 " x 9½"
Hardanger 22	5½" x 7¾"

Stitch Count: 112 x 170

Anchor	DMC (used for sample)

Step 1: Cross-stitch (2 strands)

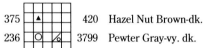

| 375 | | 420 | Hazel Nut Brown-dk. |
| 236 | | 3799 | Pewter Gray-vy. dk. |

Step 2: Backstitch (1 strand)

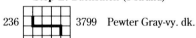

| 236 | | 3799 | Pewter Gray-vy. dk. |

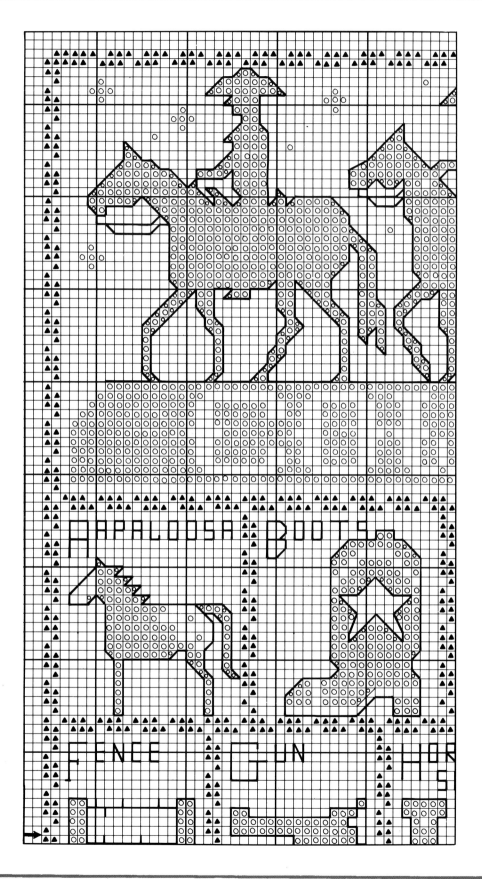

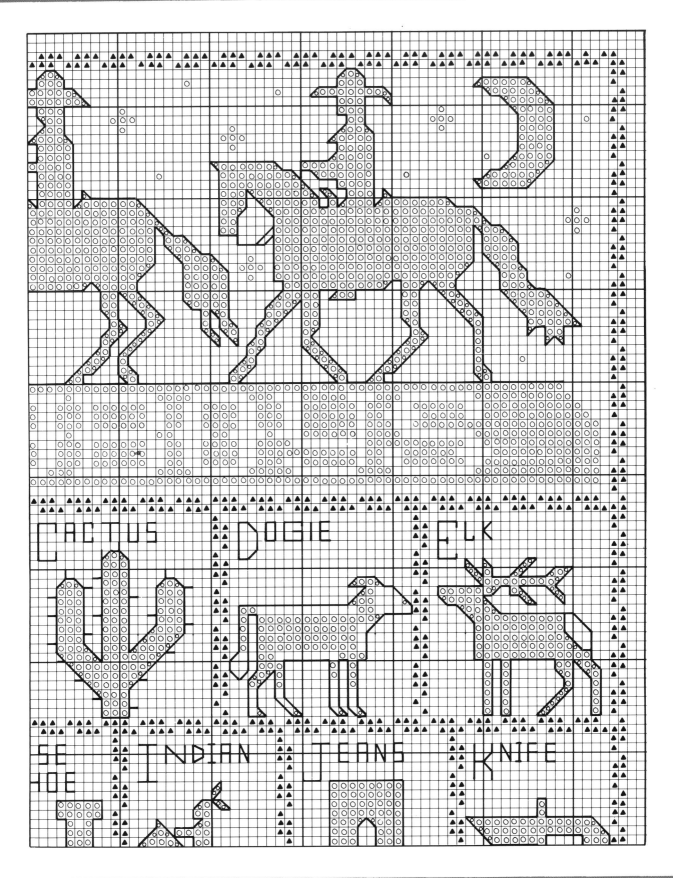

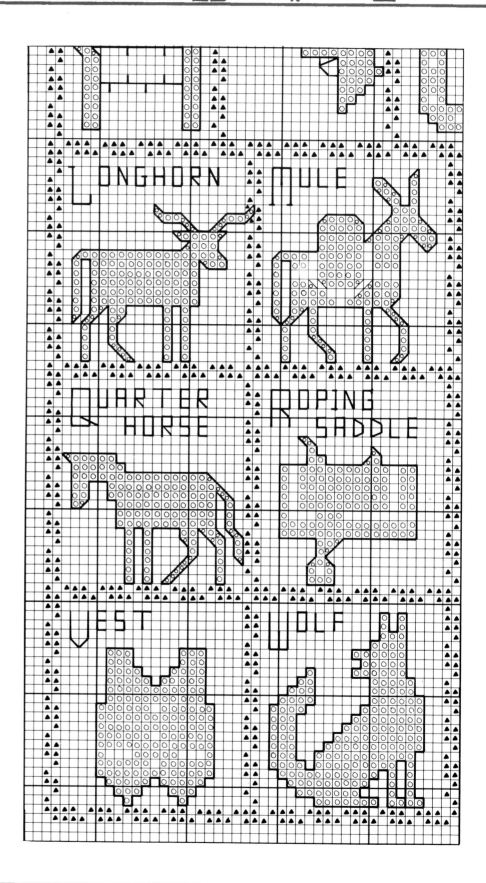

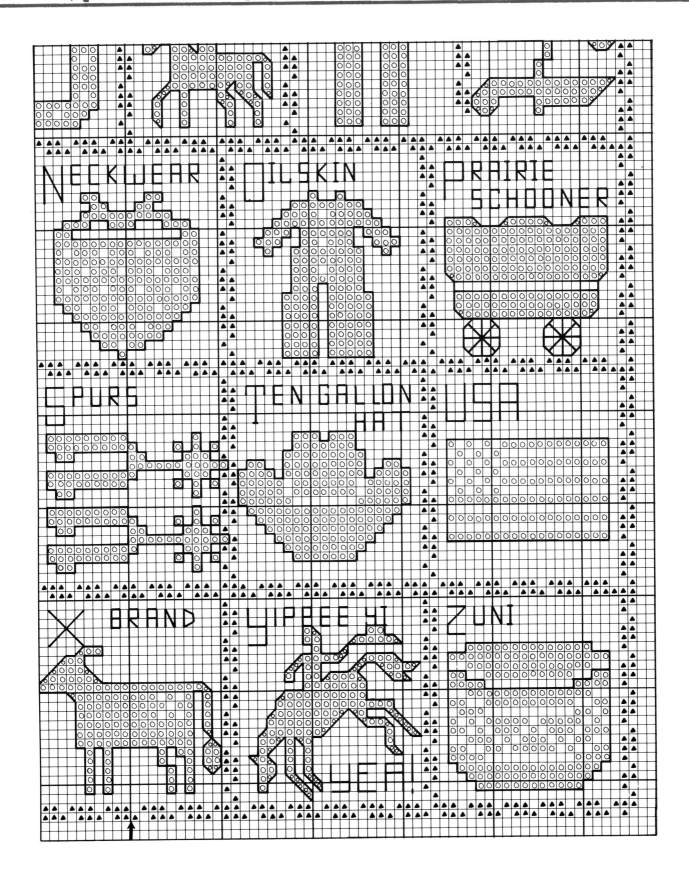

NECKWEAR OILSKIN PRAIRIE
SCHOONER

SPURS TEN GALLON USA
HAT

BRAND YIPPEE YI ZUNI
YEA!

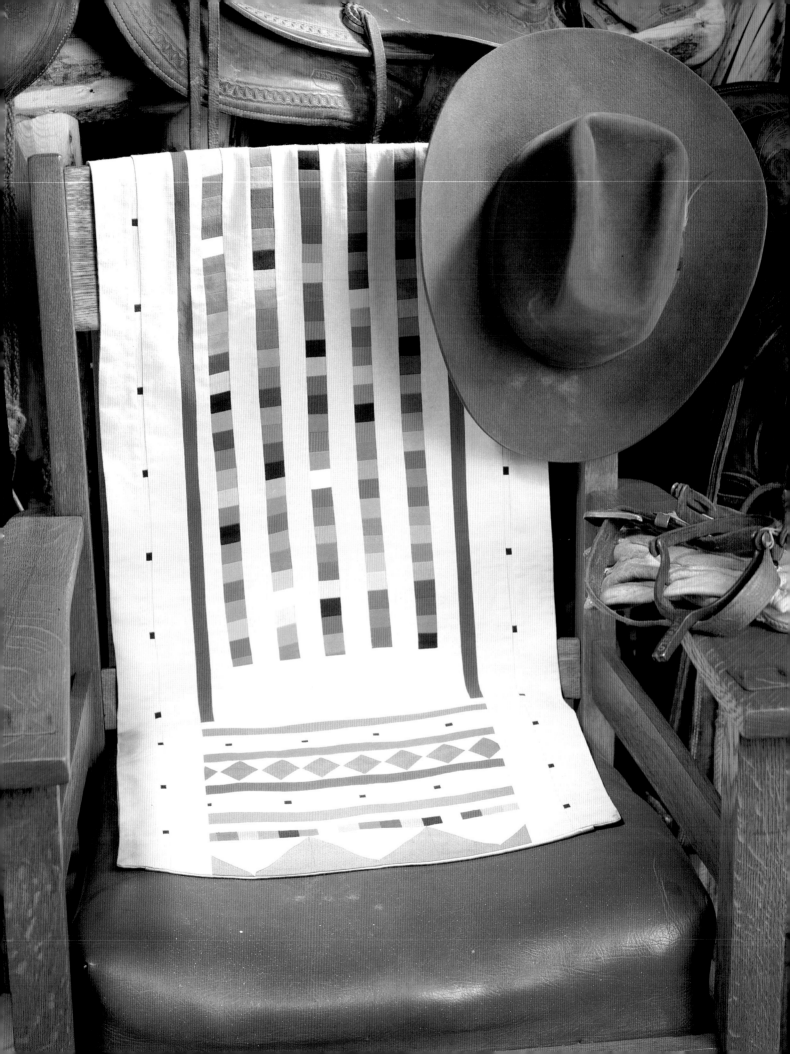

MATERIALS

2 yards of 60"-wide beige fabric; matching thread
¼ yard each of ten different colors of fabric
¼ yard of black fabric

DIRECTIONS

All seams are ¼".

Center Panel

1. Cut a 1¼" strip from each color of fabric. Sew strips together in a random color arrangement. Press seam allowances to one side. Cut 1¼" strips from the pieced fabric. Sew the pieces end to end, making five 1¼" x 30" strips and two 1¼" x 12" strips (set these strips aside for ends).

2. Cut three 1½" x 60" strips from the beige fabric. Cut each strip in half, making six 1½" x 30" strips.

3. Alternately sew beige strips to pieced strips, beginning and ending with beige. Press seam allowances toward beige. Cut ends square.

4. Cut two 3½" x 10¼" pieces from beige fabric. With edges matching, sew one piece to each end of the pieced strips. Trim excess fabric from sides.

5. Cut two 1" x 34" strips from one of the colored fabrics. With long edges matching, sew one strip to each side of the pieced strips. Press toward the beige. Trim excess fabric from the ends. Set aside.

Patchwork Ends

Pattern A
1. Cut three 3" x 60" strips from beige fabric. Cut six ¾" x 31" strips from black fabric. Sew the black strips together end to end, making three ¾" x 60" strips. Alternately sew black fabric strips to beige fabric strips, beginning with black and ending with beige. Press seam allowances toward beige. Cut ¾" strips

from the pieced fabric. Sew the pieces end to end, making two ¾" x 57" strips and four ¾" x 12" strips.

Pattern B
2. Cut two 2" x 60" strips from beige fabric. Cut four 1½" x 31" strips from one of the colored fabrics. Sew the colored strips together end to end, making two 1½" x 60" strips. With long edges matching, sew strips together, beginning and ending with beige. Press seam allowances toward beige. Cut 1½" strips from the pieced fabric.

3. Arrange the strips as shown in Diagram A. Sew together on long edges. Press seam allowances to one side. Cut top and bottom edges; see Diagram A.

DIAGRAM A

Pattern C

4. Cut two 2½" x 60" strips from beige fabric. Cut four 2½" x 31" strips from one of the colored fabrics. Sew the color strips together end to end, making two 2½" x 60" strips. Sew one beige strip and one color strip together on long edge. Press seam allowance toward beige. Cut 2½" strips at a 45° angle; see Diagram B. Repeat with remaining two strips, except press seam allowances away from beige and cut strips angled in opposite direction; see Diagram B.

5. Alternately sew Pattern C pieces together on long edges, forming a zigzag strip. Press seam allowances to one side. Trim excess fabric.

DIAGRAM B

Assembling The Ends

1. Cut twelve 1" strips from beige fabric. Cut eight 1" strips, two each from four different colors of fabric.

2. Sew each to center panel; see Diagram C. Press seams flat. Trim excess fabric from sides.

Side Panels

Cut four 2½" x 57" strips from beige fabric. With long edges matching, sew one Pattern A strip between two beige strips. Press seam allowances toward beige. Repeat with remaining strips. Sew each beige/Pattern A strip to one long side of runner. Trim excess fabric from edges.

Finishing

Cut a piece of beige fabric the same size as the runner for back. With right sides facing, stitch runner and back pieces together, leaving a small opening in one side seam. Turn. Press. Slipstitch opening closed.

DIAGRAM C

QUILTED NOTE CARD

MATERIALS

6¼" x 13½" light weight cardboard
Scraps of different-colored fabric
Glue
Craft knife

DIRECTIONS
All seams are ¼".

1. Fold long edge of cardboard in thirds like a fan. In one third of cardboard, cut 2½" x 4" window, starting 1½" down from the top and ending ¾" from the bottom, using craft knife. Set aside.

2. From scraps of fabric, cut several ½" strips. Stitch, piecing together to make 3" x 4½" piece. Lay fabric piece behind window. Stitch ⅛" from window through cardboard and fabric.

3. Glue windowed third to second third of cardboard, making a card.

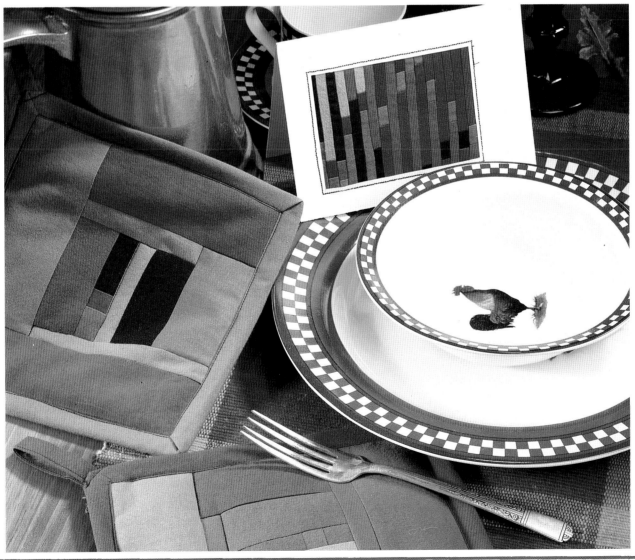

MATERIALS
12 scraps of different-colored fabrics
¼ yard of black fabric for backing; matching thread
¼ yard of burgundy fabric
¼ yard of batting
Pins
Dressmaker's pen

DIRECTIONS
All seams are ¼".

1. From black fabric, cut one 7" square for back. From burgundy fabric, cut 1½" bias strips piecing as needed to equal one 30" length for binding and one 7" length for hanger. From different colors of fabric scraps, cut the following: one 2" x 6" piece for template A, one 3½" x 2½" piece for template B, one 1" x 6" piece for template C, one 2½" x 7½" piece for template D, one 1" x 4" piece for template E, one 3" x 1½" piece for template F, one 2" x 1" piece for template G, two 1" x 1" pieces for templates H and I, one 3" x 1" piece for template J, one 3" x 2" piece for template K, and one 5½" x 2" piece for template L.

2. Sew templates together according to diagram. Press seams flat. Layer backing piece (wrong side up), fleece and design piece (right side up). Secure with pins. Mark quilting lines as indicated on diagram. Quilt.

3. Fold long edges of hanger piece inward ¼"; press. Fold hanger piece in half with long folded edges matching; press. Topstitch ⅛" from folded edge. Fold hanger in half with raw ends matching. With edges together, pin hanger to hot pad back in one corner. Trim raw edges from corners of hanger.

4. With wrong sides facing and long edge aligned, fold 30" long bias strip in half. Beginning in same corner as hanger, align raw edges of bias strip and one edge of backing. Stitch together, catching hanger in seam and mitering corners. Fold free edge of bias strip to right side of design piece. Topstitch ⅛" from edge.

5. Fold loop of hanger out from corner and topstitch to secure.

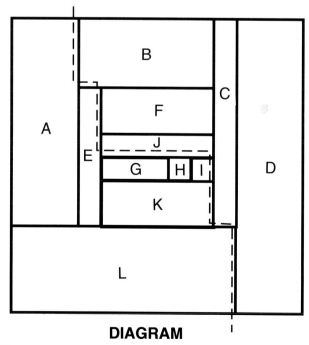

DIAGRAM

CROSS-STITCH COWGIRL

Stitched on Oatmeal Floba 25 over two threads, the finished design size is 13¼" x 9¼". The fabric was cut 20" x 16".

Fabrics	**Design Sizes**
Aida 11 | 15⅛" x 10½"
Aida 14 | 11⅞" x 8¼"
Aida 18 | 9¼" x 6⅜"
Hardanger 22 | 7½" x 5¼"

Stitch Count: 166 x 115

Anchor DMC (used for sample)

Step 1: Cross-stitch (2 strands)

8581 3022 Brown Gray-med.
382 3021 Brown Gray-vy. dk.
273 3787 Brown Gray-dk.

Step 2: Backstitch (1 strand)

382 3371 Black Brown

Step 3: French Knot (1 strand)

382 3371 Black Brown

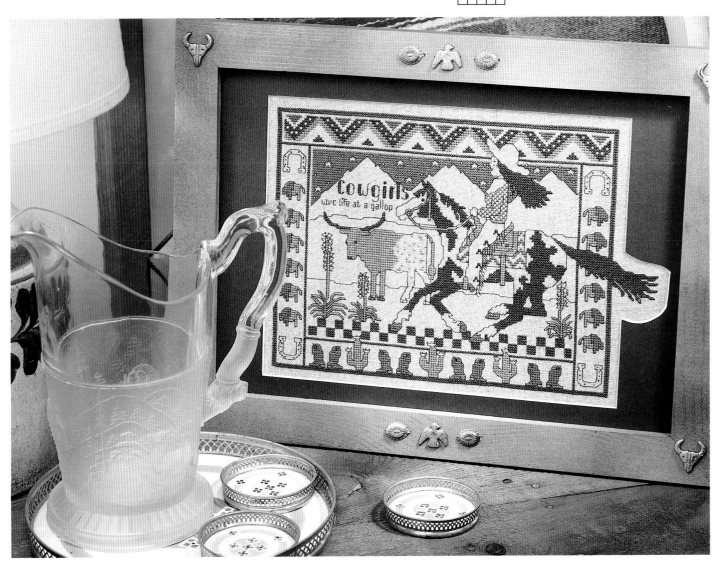

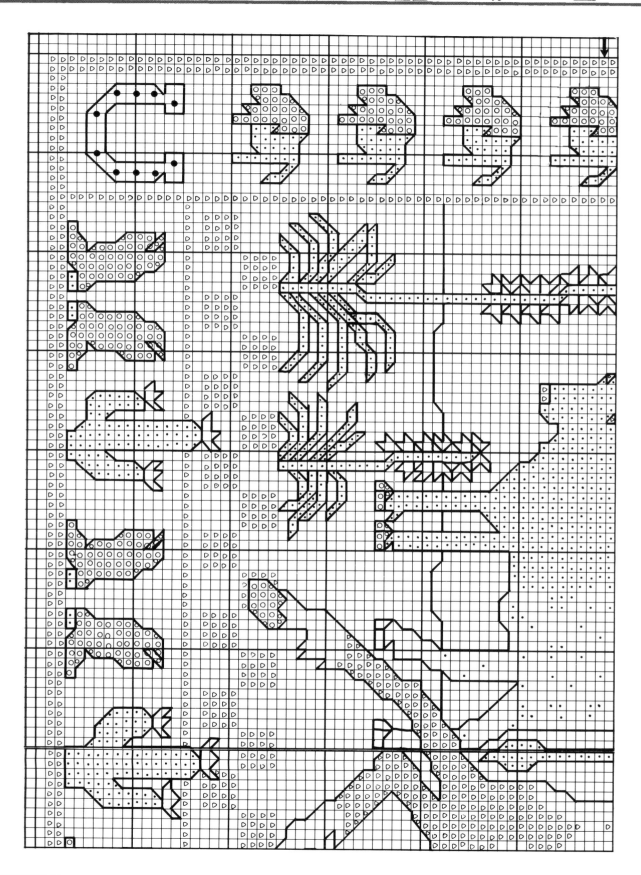

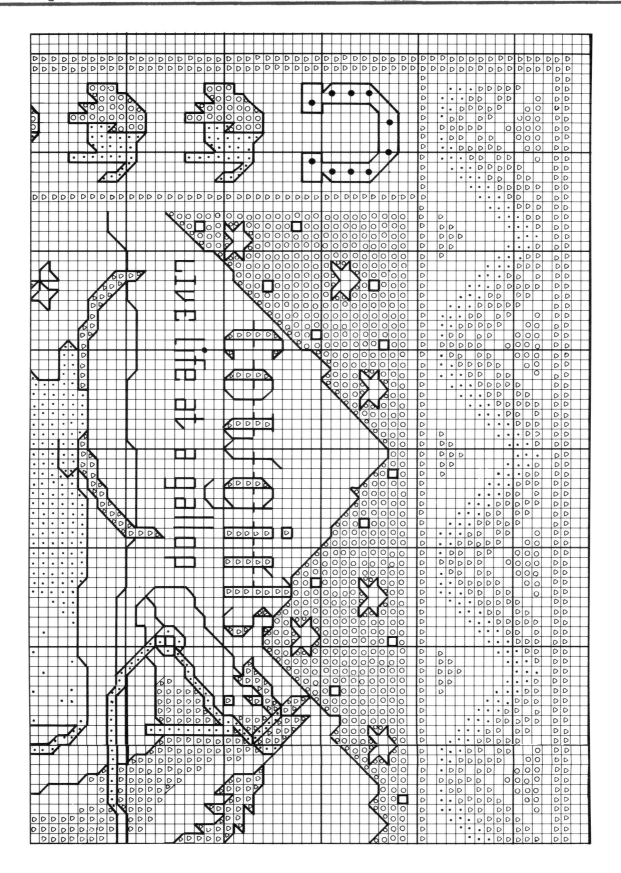

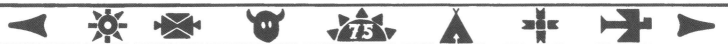

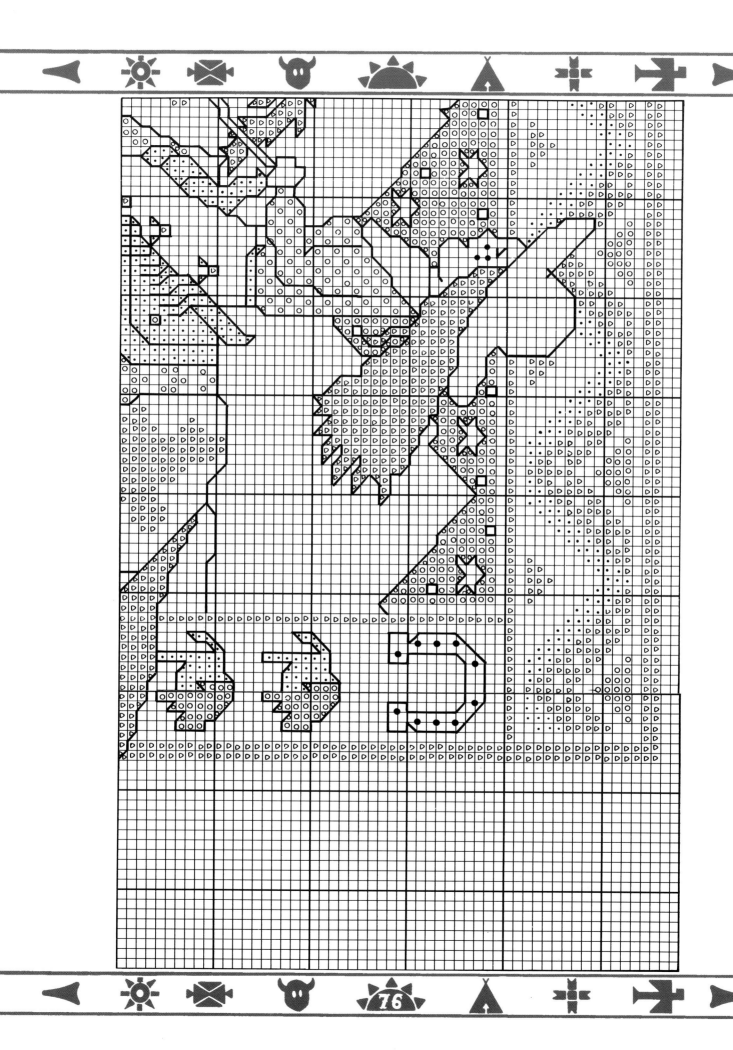

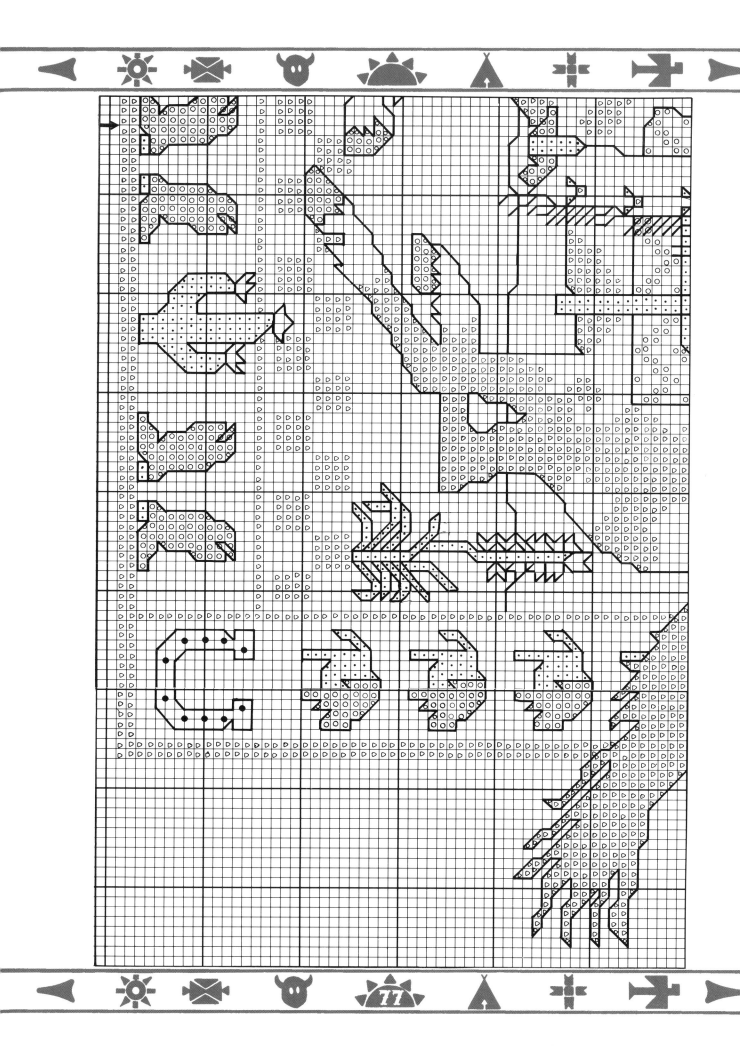

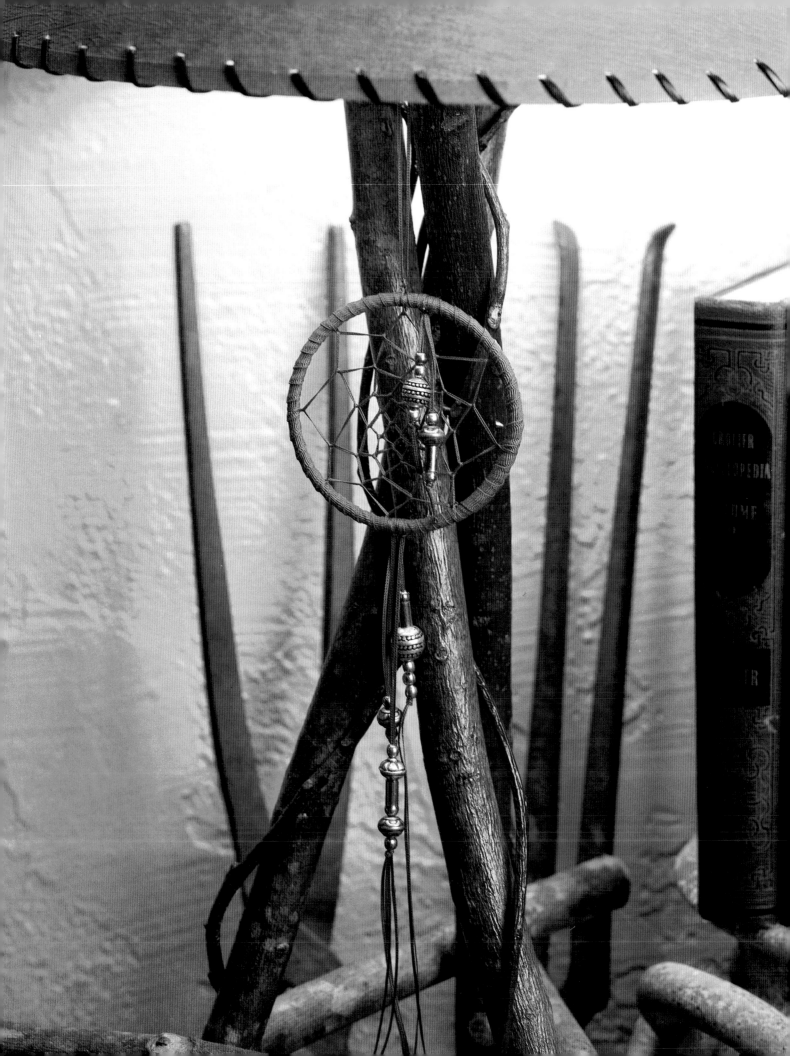

DREAM CATCHER

A Native American legend tells that all dreams are caught in the "Dream Catch." Bad dreams are caught and held by the web until they are destroyed by the first ray of sunlight. Good dreams find their way to the hoop where they enter the life of dreams through a personal adornment.

MATERIALS

One 3" metal hoop
1 yard ⅛"-wide grosgrain ribbon
3 yards ¹⁄₁₆"-wide ribbon
Silver beads: various sizes
Glue gun and glue

DIRECTIONS

1. Using grosgrain ribbon, glue one end to metal hoop. Begin wrapping hoop, being careful not to twist ribbon. Wrap until hoop is completely covered. Glue end to hoop.

2. Using ¹⁄₁₆" ribbon, cut 7" length. Tie overhand knot above glued end on hoop, forming a hanging loop; see Diagram A.

3. Tie one end of remaining ¹⁄₁₆" ribbon to hoop. Proceed around hoop, tying half-hitches at evenly spaced intervals. This will form loops; see Diagram B. Make spaces between half-hitches large or small, keeping in mind that the smaller the spaces the more intricate the finished web will be. Keep ribbon pulled snug. NOTE: Space between last half-hitch and starting point should be less than other spaces to keep a gap from forming between loops. Tie next half-hitch in center of first loop formed.

4. Continue tying from loop to loop, pulling snug, until opening at center of web is as small as desired. Tie off in a knot, as shown. Apply a small spot of glue if necessary; see Diagram C.

5. Using ¹⁄₁₆" ribbon, string beads at varying lengths and tie to hoop; see photo.

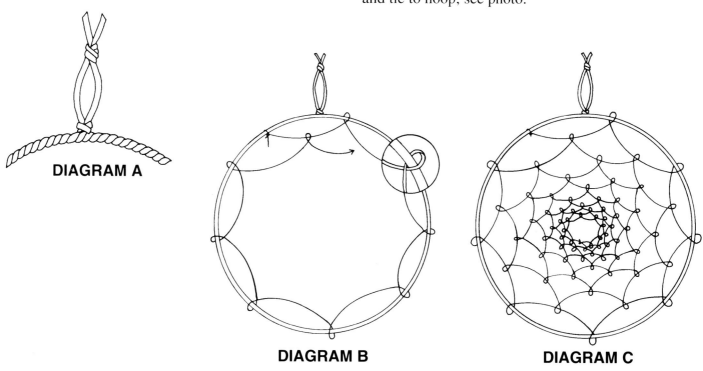

DIAGRAM A

DIAGRAM B

DIAGRAM C

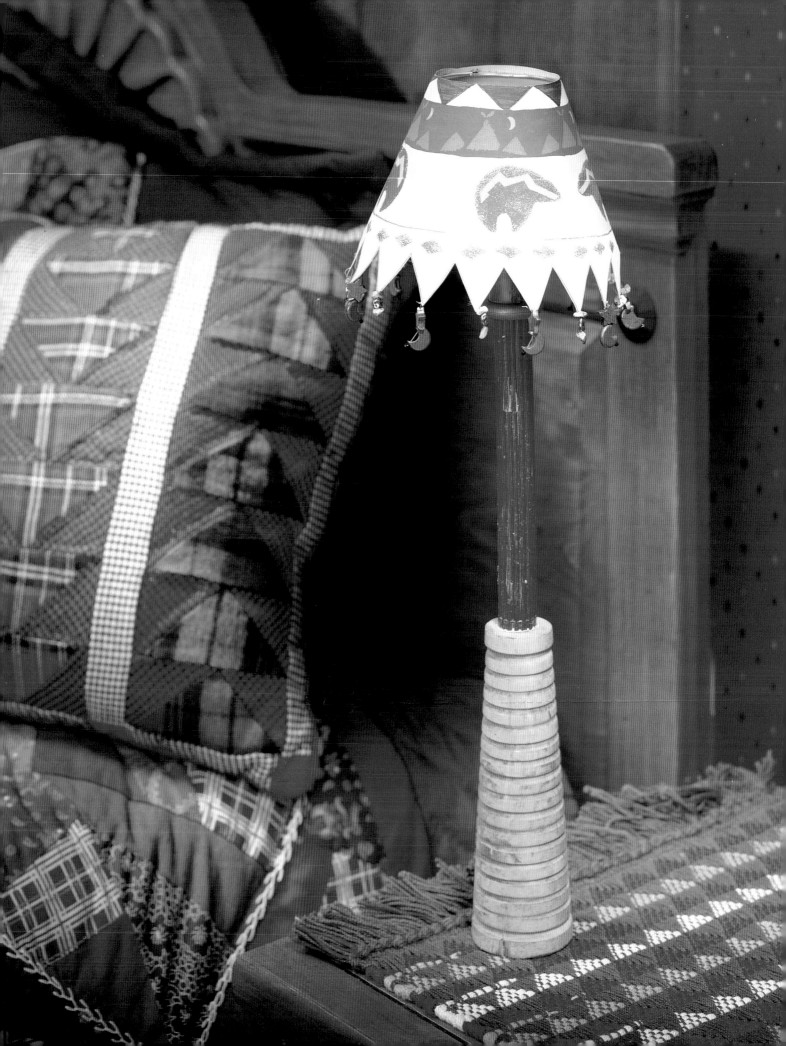

WESTERN LAMPSHADE

MATERIALS

One small purchased lampshade
One sheet of heavy paper
Nylon thread
18 turquoise chunks
Nine large silver metal beads
Nine silver star charms
Nine silver moon charms
Nine small black beads
Acrylic paints: assorted colors
Sponge
Glue
Pencil and tracing paper
Craft knife
Manila folder

DIRECTIONS

1. Make lampshade pattern. To complete pattern, flop tracing and match dotted line. From heavy paper, cut one lampshade.

2. Make stencil. Using sponge and stencil, paint design onto paper. Let dry. Glue short edges together, overlapping slightly, to form a cylinder.

3. Using nylon thread, string one turquoise chunk, one silver bead and one turquoise chunk. Attach to one point on bottom edge of lampshade. String one star, moon and black bead. Attach to point of lampshade beside turquoise string. Repeat, alternating star strings and turquoise strings; see photo.

STENCIL PATTERNS

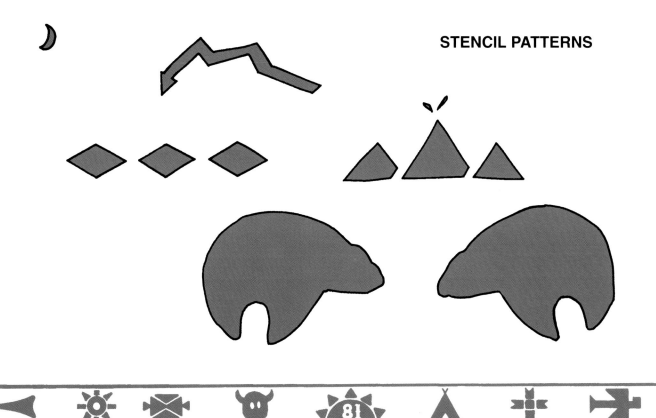

LAMPSHADE PATTERN

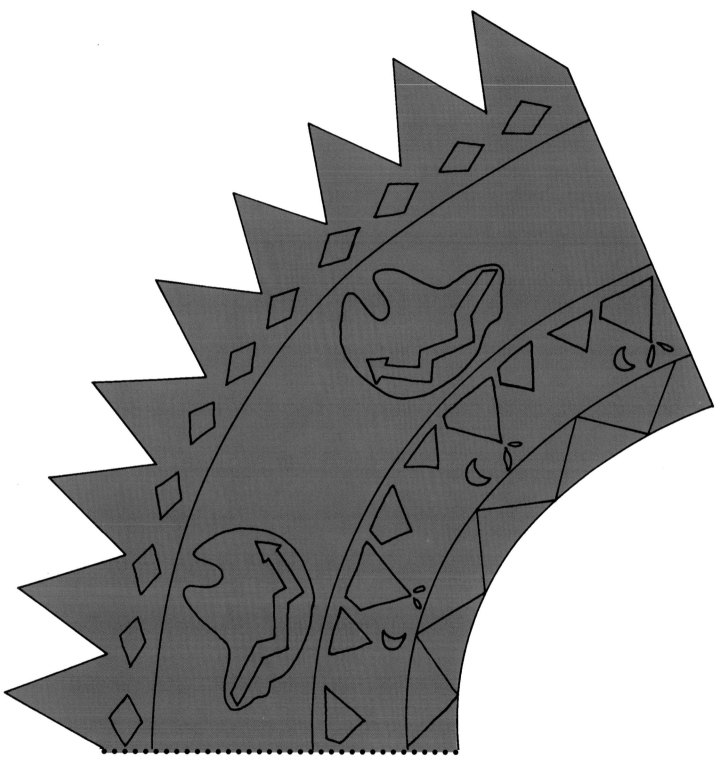

Flop along dotted line

82

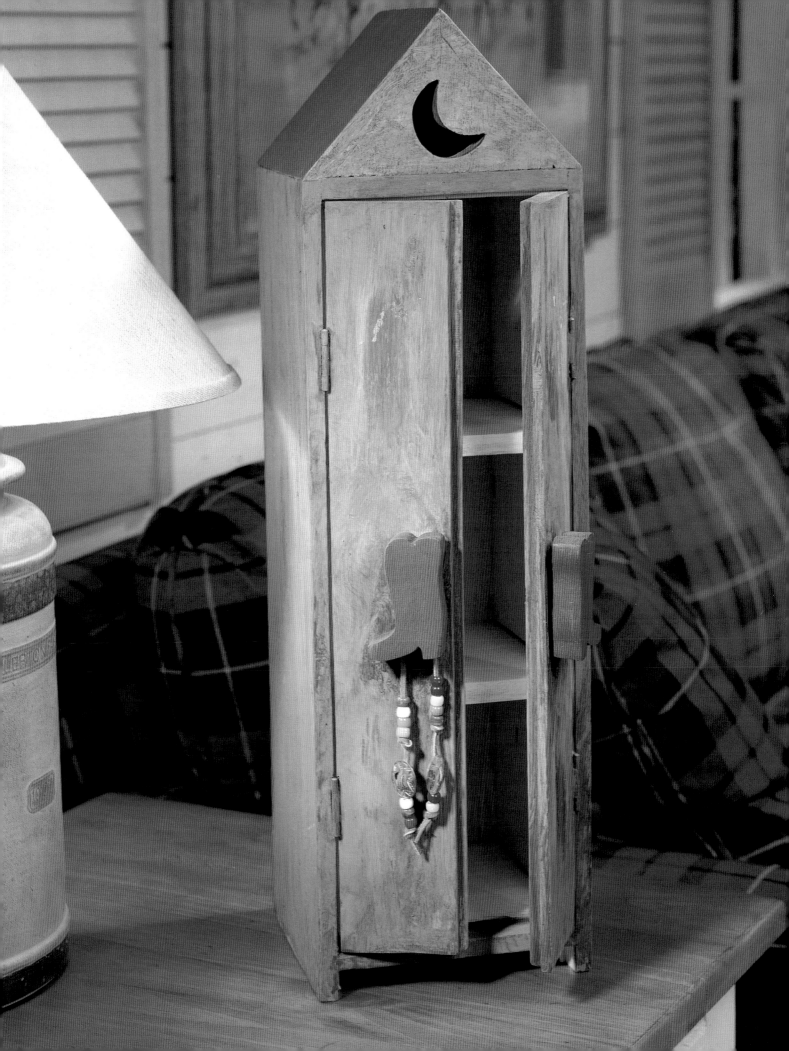

COUNTRY CUPBOARD

MATERIALS

One 7" x 7½" x 25" purchased cupboard with triangle top
One 4" x 6" x ¾" piece of pine wood
2" length of ½" dowel
Acrylic paints: assorted colors
Jigsaw
Drill with ½" drill bit
Wood glue
20" length of ⅛" leather strip
Two gold conchos
14 large plastic beads: assorted colors

DIRECTIONS

1. Make moon and boot patterns. From ¾" pine, cut two boots. Cut dowel into four ½" lengths. Trace moon on front top triangle piece. Cut out with saw.

2. To make handles, mark placement of two holes on front doors and matching holes on wrong side of boots. Drill, making sure you do not drill all the way through wood. Insert and glue dowels to boots and then to doors.

3. Paint as desired; see photo. String nine plastic beads onto leather strip, knotting each strip 4½" from ends. Slide a concho on each end. Add remaining beads and tie another knot on each end. Drape leather over one boot doorknob.

MOON PATTERN

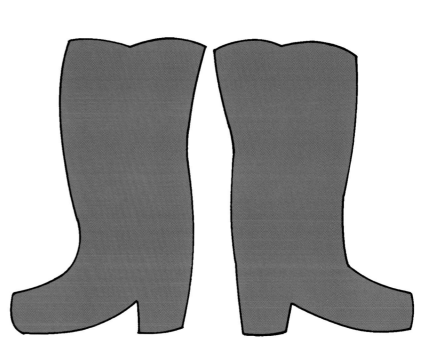

BOOT PATTERN

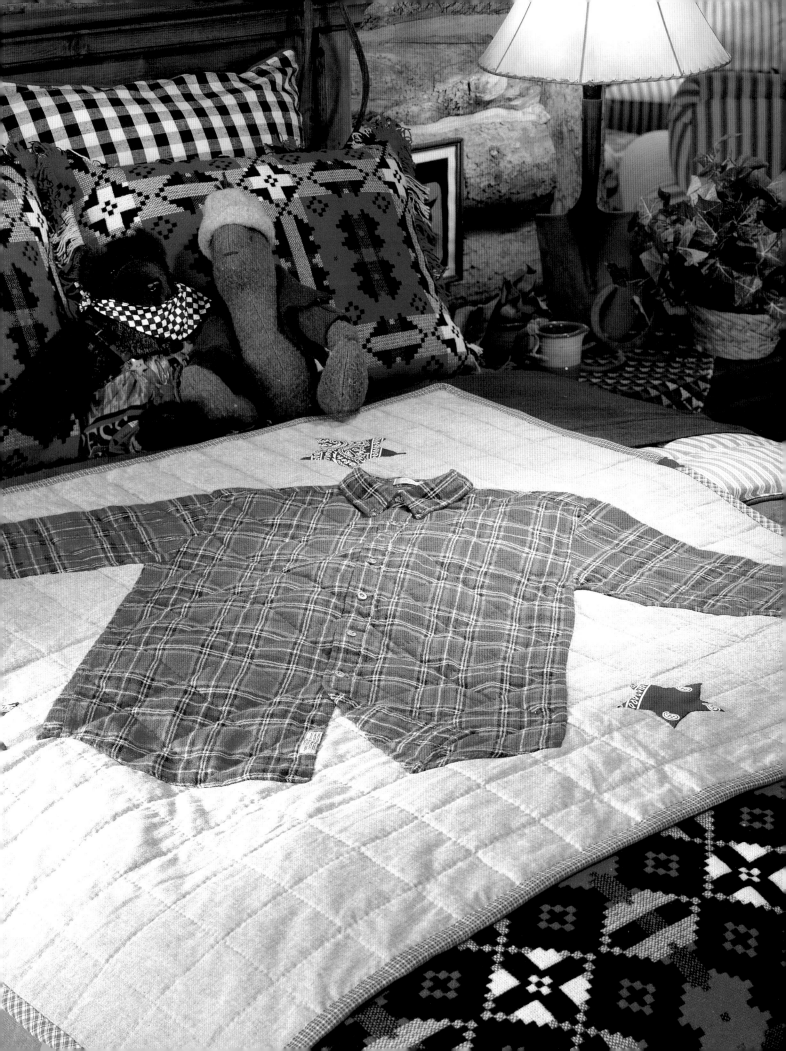

COWBOY QUILT

MATERIALS

One purchased small-sized flannel shirt;
 matching thread
2⅔ yards of solid-colored fabric; matching thread
¾ yard of four different-colored calico fabrics
One navy bandanna; matching thread
44" x 48" piece of fleece
Dressmaker's pen
Straight pins

DIRECTIONS
All seams are ¼".

1. Make star pattern. From navy bandanna, cut three stars. From solid fabric, cut two 44" x 48" pieces for front and back of quilt. From calico fabrics, cut 2"-wide bias strips, piecing together to make a 190" patchwork strip.

2. Lay shirt flat. Cut away back side of sleeves and shirt along seam lines and yoke line. Lay shirt diagonally on right side of solid fabric; pin in place. Turning under all edges ¼", hand-stitch to fabric. Place stars at random, stitch turning under all edges ¼"; see photo.

3. Layer fleece between wrong sides of quilt top and back. Pin all edges together. Mark top of quilt in 3" squares. Quilt through all layers.

4. Trim backing and fleece to match quilt top. With right sides facing, sew patchwork binding to quilt top. Fold binding double to quilt back. Slipstitch binding to quilt back, mitering corners.

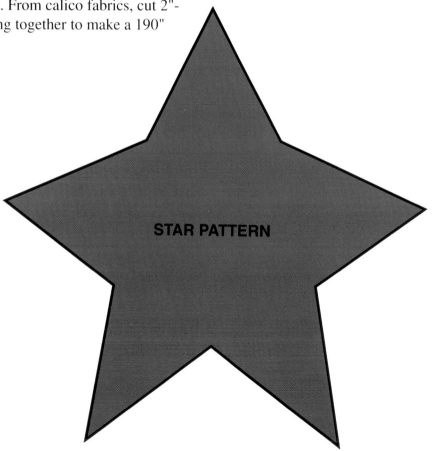

STAR PATTERN

BEADED PICTURE PINS

MATERIALS

2½" x 3" piece of 24-gauge tooling copper or brass
2" x 2½" piece of glass
Photo to fit
3 yards of 18-gauge copper wire
Silver charms: cowboy hat, saddle, boot, feathers, and stars
Glass and plastic beads: assorted sizes, shapes, and colors
1½" pinback
Soldering iron and resin core solder

DIRECTIONS

1. Using tooling copper or brass, layer photo and piece of glass in center. Cut corners of metal diagonally to corner edge of glass. Bend copper or brass up against glass; crease. Fold copper or brass over onto glass, overlapping corners.

2. Thread beads and charms onto wire, twisting and turning as desired. Wrap around itself, overlapping around entire edge of frame. Solder in place; see photo.

3. Solder pinback to back of frame.

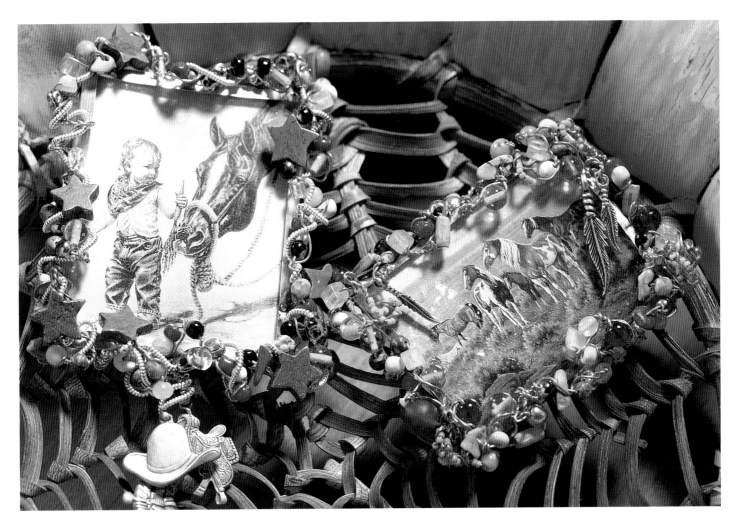

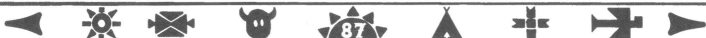

RED-PEPPER
DOOR HANGER

MATERIALS

1" x 12" x 24" piece of white pine wood
Red acrylic paint
Walnut stain
Raffia
Jigsaw
Drill with a ¼" bit
Medium sandpaper
Paintbrush
Rags

DIRECTIONS

1. Make pepper pattern, transferring all lines. Using jigsaw, cut 12 peppers from wood.

2. Using electric drill, drill a ¼" hole on each pepper where indicated on pattern.

3. Using red paint, mix two-parts paint with one-part water; paint all peppers. Brush on walnut stain and quickly wipe off excess with rags. Sand all edges creating an antiqued effect.

4. Thread two strands of raffia through each pepper at varying lengths. Holding all strands as one, form a loop and tie a knot. Hang peppers on wall or door from loop.

PEPPER PATTERN

FRONTIER PICTURE FRAME

MATERIALS

One purchased 17" x 27" flat wood frame with
 13" x 23" window
Acrylic paints: assorted colors
Clear acrylic matte finish spray
Paintbrushes
One saw-tooth wall hanger and nail set
Hammer

DIRECTIONS

1. Using acrylic paint, paint inside and outer edges of frame. Using contrasting color, paint the front of the frame. Using colors as desired, paint design; see photo.

2. When dry, seal with clear acrylic matte spray. Let dry.

3. Find center top back of frame. Using hammer, nail on saw-tooth wall hanger.

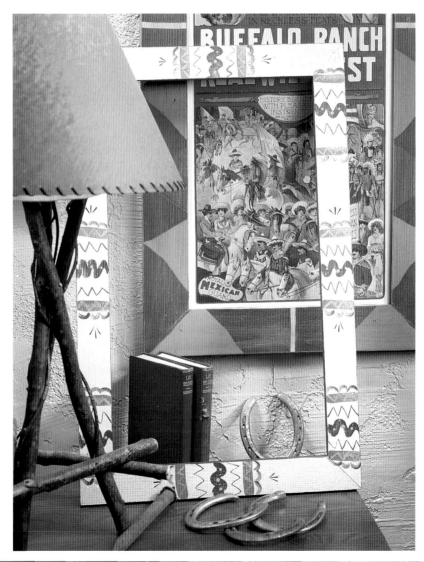

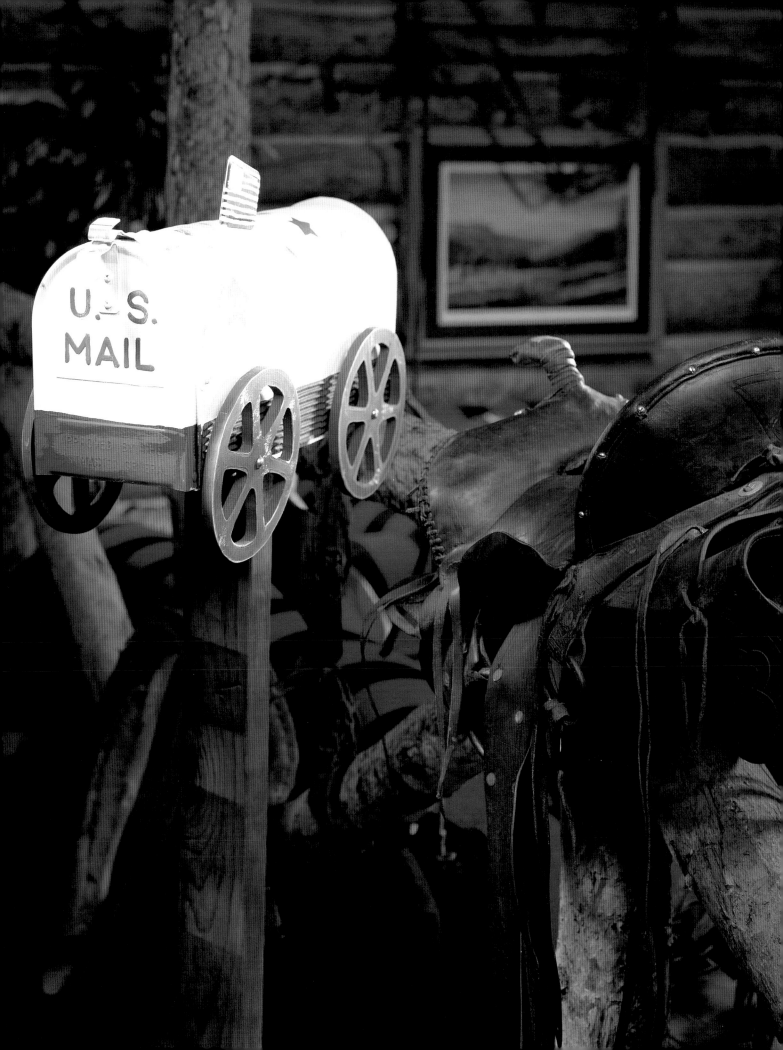

MATERIALS

One standard-size metal mailbox
1 yard of canvas
8" x 30" x ½" piece of pine wood
Acrylic paints: blue, white, red, and brown
Paintbrushes
Corrugated cardboard
Four nuts and bolts
Spray adhesive
Hot glue gun and glue
Drill with ½" bit
Four 2" x ⅜" bolts and nuts
Eight ⅜" washers (for wheel spacer)
Jigsaw
Needle and thread

DIRECTIONS

1. Make wheel pattern. From wood, cut four wheels. From canvas, cut one 21" x 25½" piece. From corrugated cardboard, cut two 2½" x 19" lengths and one 2½" x 6½" length.

2. Spray top and sides of mailbox with spray adhesive. Run a bead of hot glue along seam of back end of mailbox, attaching canvas 3" from long side edge. Turn long side edge under ¼". Run a gathering stitch along folded edge. Gather edge to form door; see Diagram A. Measure 5½" from edge and make a 1" tuck; hot-glue to mailbox. Measure 2" from first tuck and make a second 1" tuck; hot-glue. Measure 4" from second tuck and make a third 1" tuck; hot-glue. Measure 2" from third tuck and make final 1" tuck; hot-glue. Hot-glue remaining canvas inside mailbox opening. Tucks will resemble ribs in covered wagon; see Diagram B. Stretch canvas snugly across top of mailbox and glue securely to bottom side of mailbox.

3. Paint entire mailbox white, including canvas and flag. Let dry.

4. Hot glue lengths of corrugated cardboard at bottom edge of mailbox along sides and back. Do not cover door.

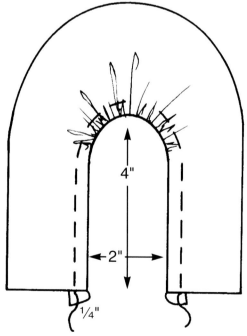

4"

2"

¼"

DIAGRAM A

5. With brown paint, paint corrugated cardboard, bottom 2½" of door, and wheels. Also with brown paint, dry-brush accents on canvas to create dirt marks; see photo. Using blue paint, paint wheel design, "U.S Mail," stars and star field on flag. Using red paint, paint stripes on flag.

6. Mark placement for wheels on mailbox; see Diagram B. Drill a hole in center of each wheel and marked place on mailbox. Place two washers between wheels and mailbox. Hold in place with nuts and bolts.

DIAGRAM B

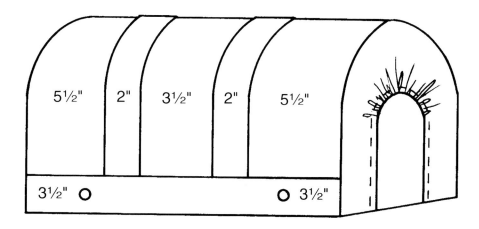

WHEEL PATTERN

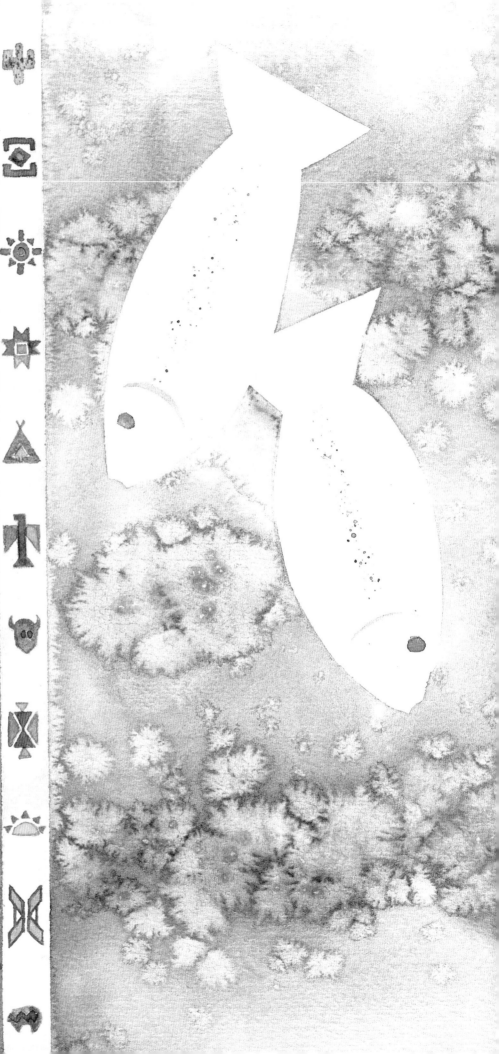

Now I have shod horses
 for quite awhile,
But it's mostly people
 that make me smile.
Why I got a call from a
 lady one day.
She said, "Now, I've got
 something to say.

So listen if you will 'til I've
 made my plea.
Then you can tell me if
 you'll agree.
I've got this horse and
 he's got sore feet,
But I've only got just
 enough money to eat.

So I wonder if maybe
 you'd shoe my horse
If I baked you some bread?"
 Well, I said, "Of course."
And when I thought it over,
 I chuckled a bit
'Cuse the IRS would have a fit.

Well, I shod that horse for some
 homemade bread
With visions of pleasure
 in my head.
But when I tried to cut the stuff,
Talk about bread being
 hard and "tuff".

So I had to slice it with
 an old hack-saw.
And I felt like I was
 abreakin' the law.
I couldn't eat it or
 shoot it for skeet,
So I nailed those slices on the
 horses feet.

—Don Kennington

NO GO WAGON FOR THE CHUCKWAGON

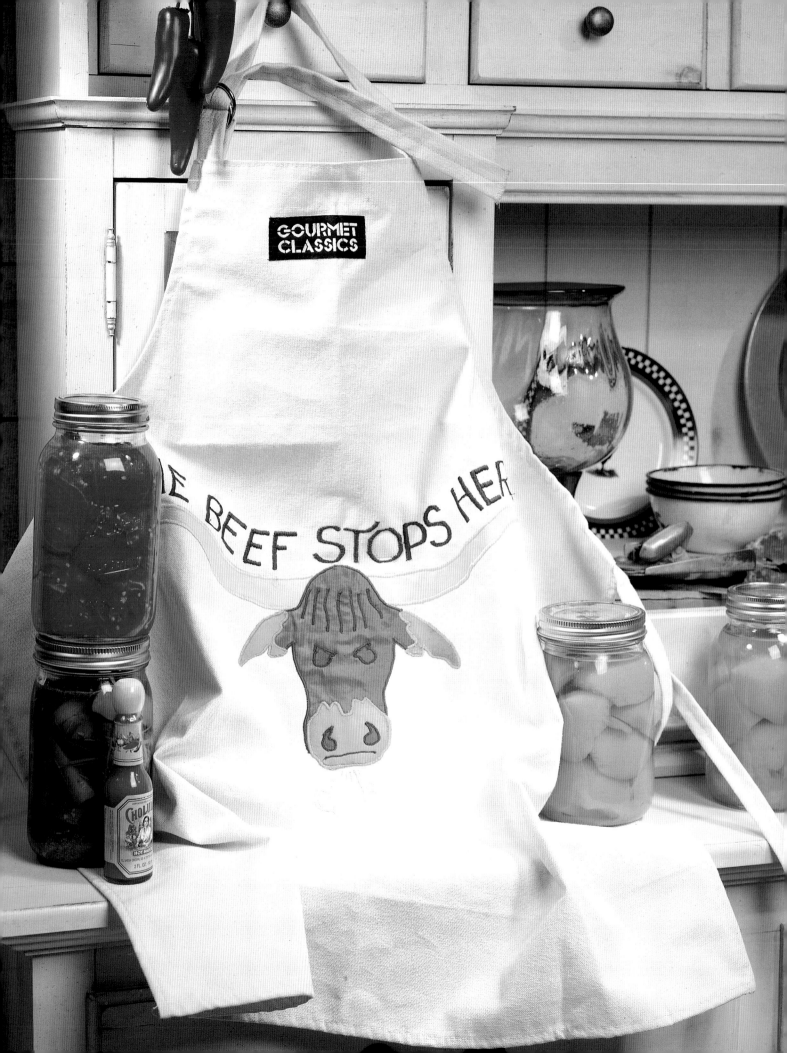

LONGHORN BAR-B-Q APRON

Every good chuckwagon cook knows that having the proper apron is just as important as getting the spices right. You can use this fine sample of BBQ apron art on any size apron by reducing or enlarging the patterns on a copy machine. Works on a sweatshirt or the back of a denim jacket, too!

MATERIALS

Purchased butcher-style apron
Pencil and tracing paper
19" x 12" piece of fusible webbing
Dressmaker's pen
Iron
9" x 9" piece of rust chintz fabric for steer face; matching thread
9" x 7" piece of tan fabric for horns; matching thread
Scrap of brown fabric for muzzle and ears; matching thread
Scrap of dark brown fabric for eyes and nostrils; matching thread
20" x 14" piece of fusible tear-away
Light blue thread
Sewing machine with embroidery foot

DIRECTIONS

1. Trace the steer and lettering patterns and steer snort pattern. To complete steer face, flop tracing and match dashed lines. To complete line of lettering, match dots.

2. Transfer steer patterns to paper side of fusible webbing, drawing nostrils and eyes separately. Leave ½" between pattern pieces. Cut out, leaving space intact between each; do not remove paper. Fuse rough side of steer face to rust chintz, horns to tan fabric, muzzle and ears to brown fabric, eyes and nostrils to dark brown fabric. Cut out appliqués. Remove paper.

3. Center steer face horizontally on apron; fuse. Fuse horns, muzzle, ears, eyes and nostrils in place; see photo.

4. Transfer lettering to apron above steer horns. Draw steer mouth on muzzle according to pattern. Transfer steer snort to apron below muzzle.

5. Center shiny side of tear-away behind appliqués, lettering, and steer snort on wrong side of apron. Iron.

6. Machine satin-stitch around appliqués with matching threads; see photo. Satin-stitch lettering and steer forelock hair in dark brown and steer snort in light blue. To remove tear-away, make a small scissor cut in portion on wrong side of apron; lift and tear.

7. To remove tear-away, make a small scissor cut in portion of tear-away backing appliqués. Lift and tear.

Jake's Quick Cowboy BBQ Sauce

Purchased BBQ sauce
Three to four dashes of Worcestershire sauce
Dash of brown sugar
Garlic powder to taste
Dash of red pepper (easy, now!)
Few teaspoons of water as needed to thin

Tips: Use hot coals, not high flame, sprinkled with a few hickory or mesquite chips. Keep sauce simmering on one corner of the grill; stir often, scraping sides of pot. Brush sauce on when meat is almost done. Turn meat frequently so that sauce doesn't burn and stick. Wear this apron.

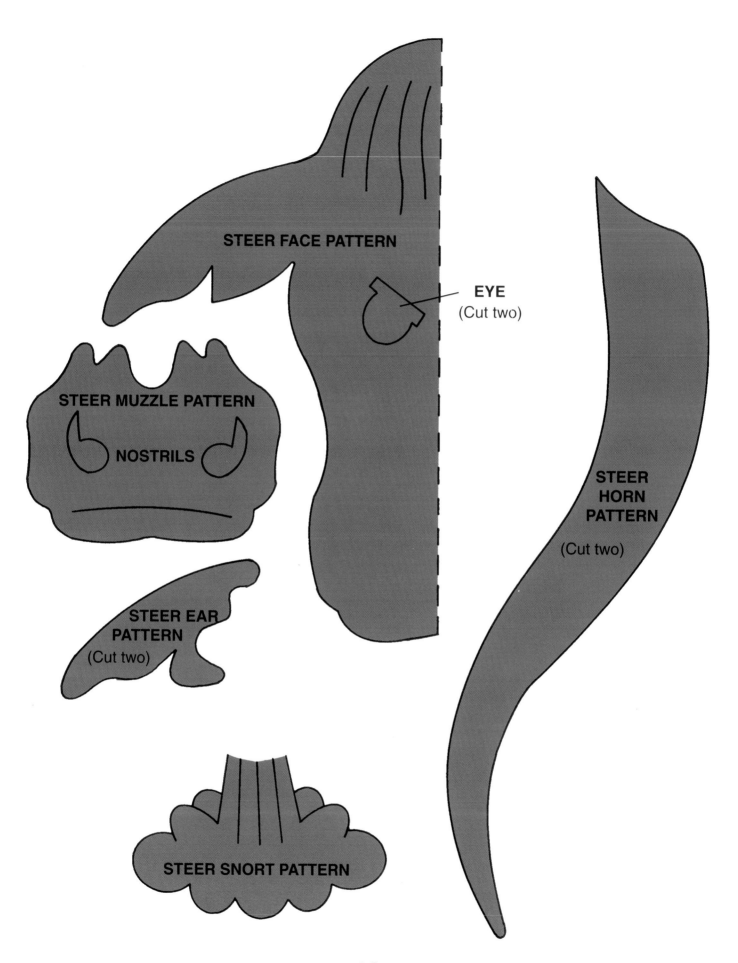

STEER FACE PATTERN

EYE
(Cut two)

STEER MUZZLE PATTERN

NOSTRILS

STEER HORN PATTERN

(Cut two)

STEER EAR PATTERN

(Cut two)

STEER SNORT PATTERN

LEATHER JAR LABELS

MATERIALS

One 8"x 11" piece of leather
Two 48" lengths of ⅛" leather laces
Acrylic paints: assorted colors
Small-hole paper punch

DIRECTIONS

1. Make label pattern. From leather, cut two labels. Make stencils.

2. Using stencil, paint design; see photo.

3. Punch six holes on each short edge. Thread laces through holes; tie around jars.

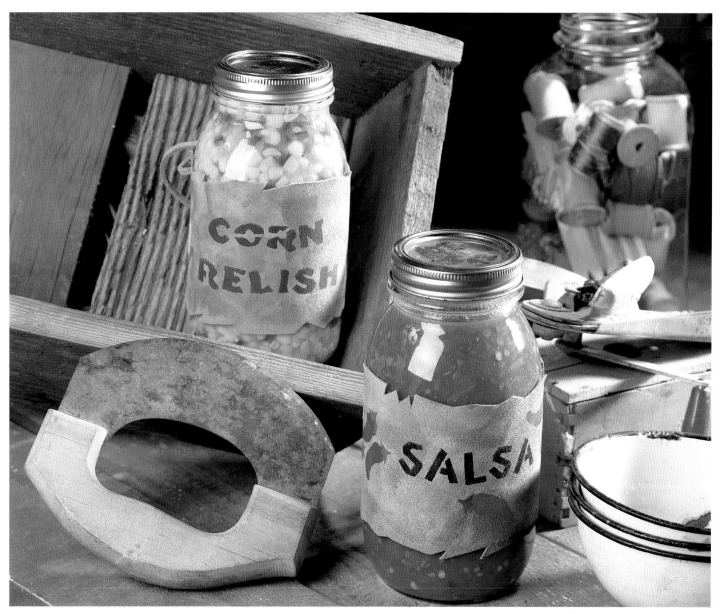

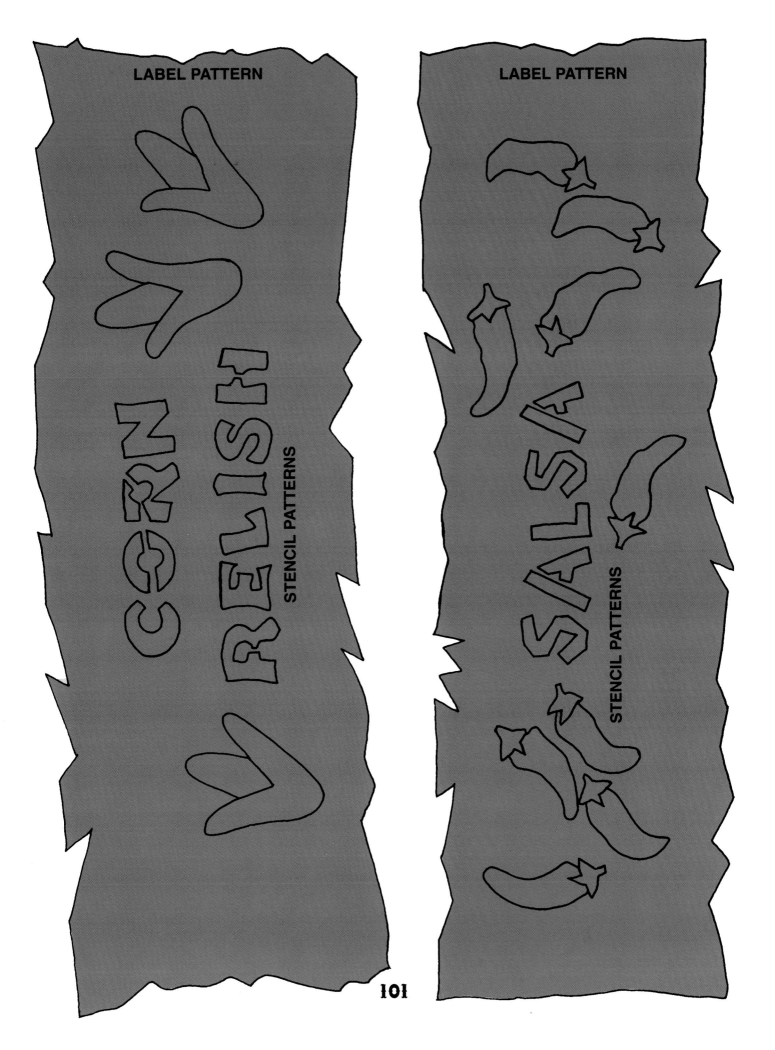

CORN RELISH

STENCIL PATTERNS

SALSA

STENCIL PATTERNS

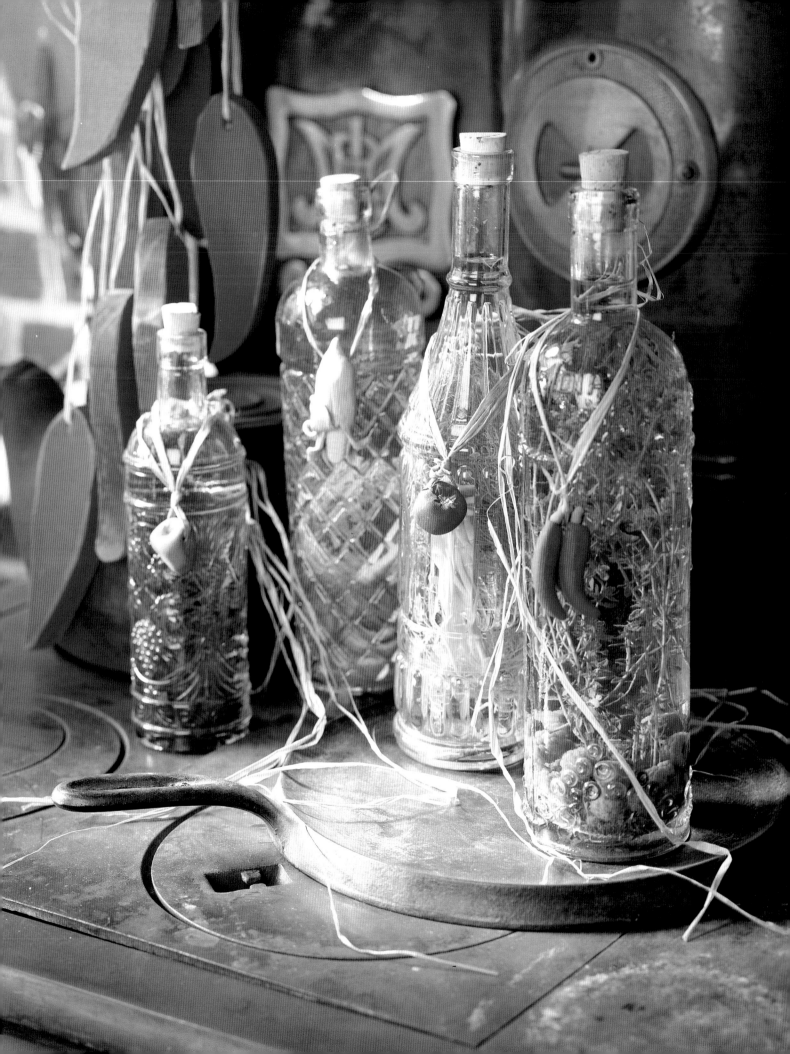

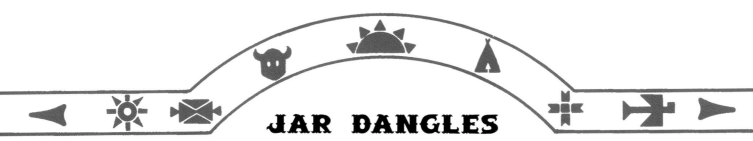

JAR DANGLES

This fun project is perfect for your littlest ranch hands! These miniature vegetables—corn, chili peppers, tomatoes, green peppers—are made to decorate herb vinegar bottles, salsa jars, any container you want to dress up.

MATERIALS (for hangers shown)

Polymer clay: red, white, green, yellow
Paring knife
Round toothpick
Acrylic paints: light green, olive green, and brown
Paintbrushes
Raffia

DIRECTIONS

1. To make chili peppers, roll red clay into three small tubes of varying lengths. Taper ends, curving peppers slightly. Stack peppers together. Make stems from green clay. Use toothpick to make hole for hanger.

2. To make corn, make cob first, using yellow clay. Use point of knife or tip of toothpick to draw kernels. Make husks from white clay, curling ends back. Wrap husks around cob, smoothing toward bottom end. Use toothpick to make hole for hanger.

3. Make green pepper from green clay and tomato from red clay. Use toothpick to make holes for hangers.

4. Bake clay according to manufacturer's directions. Paint corn husks light green with olive green stripes. Paint tomato stem brown.

5. Thread raffia through hole in each item. Knot raffia; then tie ends around bottle or jar.

Other Things To Make:
Sombrero
Horseshoe
Cactus
Cowboy boot

 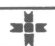 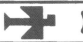

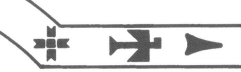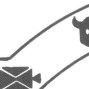

RANCHER RECIPES

Hot! Hot! Salsa
INGREDIENTS

25 tomatoes
5 onions
20 jalapenos
16 chili peppers
5 bell peppers
2 cups of vinegar
½ cup of sugar
3 Tablespoons of salt

Hot Salsa
INGREDIENTS

25 tomatoes
5 onions
10 jalapenos
8 chili peppers
5 bell peppers
2 cups of vinegar
½ cup of sugar
3 Tablespoons of salt

Mild Salsa
INGREDIENTS

25 tomatoes
5 onions
5 jalapenos
4 chili peppers
5 bell peppers
2 cups of vinegar
½ cup of sugar
3 Tablespoons of salt

DIRECTIONS

1. Peel tomatoes. Cook for three hours or until as thick and hot as you want. Cold-pack for 20 minutes.

2. Cook by single batches only. Makes 10 to 12 pints.

Corn Salsa
INGREDIENTS

1 dozen ears of corn
2 large onions
2 Tablespoons of mustard
1 sweet red pepper
1 small head of cabbage
½ teaspoon of turmeric
¼ cup of flour
1½ cup of sugar
4 cups of vinegar
¼ cup of salt

DIRECTIONS

1. Cut corn from cob. Chop pepper, onion, and cabbage.

2. Heat to boil. Add 2 cups of vinegar. Cook ½ hour. Add all remaining ingredients and cook to desired consistency.

Woodland Blend Potpourri Recipe
INGREDIENTS

2 cups of wild strawberry leaves
1 cup of pine needles
½ cup of rosemary
¼ cup of cedar wood chippings
¼ cup of patchouli
¼ cup of rosewood
3 drops of cypress oil
2 drops of pine oil
1 ounce of oakmoss
2 Tablespoons of sweet violet root

DIRECTIONS

Mix all dry ingredients together. Add oils; mix. Place in sealed bottle or bag and let sit in a dark place for three to six weeks.

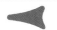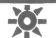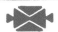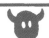

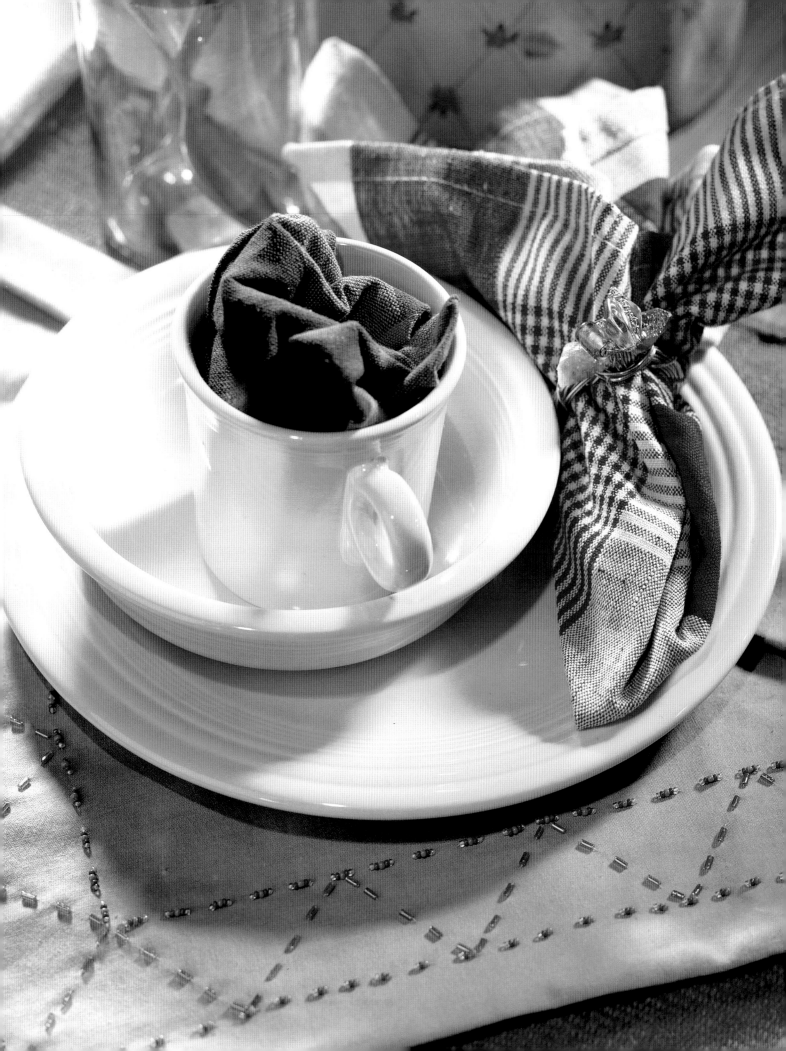

PLACE MAT & NAPKIN RING

Place Mat
MATERIALS

½ yard of fabric; matching thread
130 amber bugle beads
300 green 11/0 seed beads
300 amber 11/0 seed beads
200 orange 11/0 seed beads
Dressmaker's pen

DIRECTIONS
All seams are ½".

1. From fabric, cut two 18" squares. Using pen, draw design onto right side of one square of fabric 1½" from outer edge.

2. Stitch bugle beads in zigzag pattern. Using 11/0 seed beads, stitch along outer line in set of three. Stitch beads from left to right, one green, one amber and one orange. Repeat around fabric square, allowing ¼" space between each set. Following inside line, stitch sets of four seed beads, starting with one green, one amber, one orange, one amber and one green. Repeat around fabric square, allowing ¼" space between each set.

3. To make place mat, with right sides facing, aligning all edges, stitch leaving small opening. Trim and turn. Whipstitch opening closed. Press.

Napkin Ring
MATERIALS

One treated 1¾" x 2" long quartz crystal
4 yards of 18-gauge copper wire
One spool of 36-gauge copper wire
One ¾" bead
One ½" bead

DIRECTIONS

1. Wrap 18-gauge copper wire, making a 1¾" ring. Wrap end of wire around bundle of wrapped wire to secure. Set crystal on top of ring, wrapping wire around crystal four or five times to secure; see photo. Let remaining wire hang free.

2. Set larger bead on top of crystal, using 36-gauge wire; attach to crystal. Twist wire to make pattern on top of bead; see photo. Set smaller bead in place next to larger bead; secure with wire. Using remaining 18-gauge wire, wrap around beads and crystal to secure; tuck end under crystal and trim.

CLAY CANDLEHOLDERS

New Mexico nights are beautiful in any season. In summer, you'll see courtyards lit by soft candlelight while guitars play. Around Christmastime, luminaires glow on walkways and windows are bright with candles. These candleholders will add the romance of Old Santa Fe to any home, from cowboy cabin to cattle baron ranch.

MATERIALS

Terra cotta flowerpots in assorted sizes
Terra cotta pot saucers (optional)
Metallic silver spray paint
Four turquoise and silver conchos per pot
Hot glue gun and glue sticks
Plain or scented candles to fit pots

DIRECTIONS

1. Spray-paint pots inside and out with metallic silver paint. Apply two coats, if needed, allowing paint to dry between coats. Turn pots upside down to spray bottoms. If using pot saucers, paint in the same manner. For an old-time look, use tape to remove some of the paint, allowing the terra cotta to show through. Or use a small nail or a pin to scratch through the paint.

2. Glue four conchos, evenly spaced, around neck of each pot.

3. Put a candle in each pot. If not using pot saucers, make sure pots sit on a nonflammable surface when burning candle.

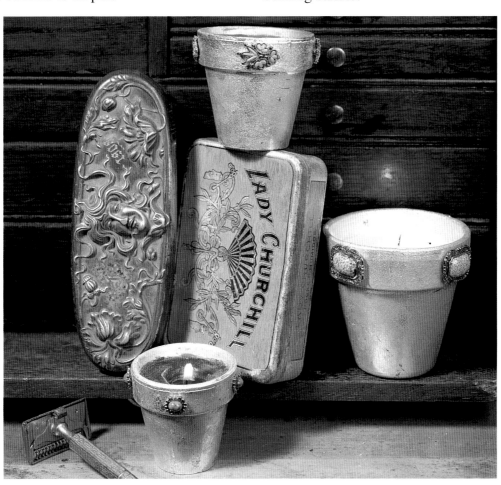

When the final

 round-up's over

and the cattle's

 home at last,

and the hay is in

 the stackyards and

our summer time

 has passed,

and bees are in

 the beehive

and the honey's

 in the comb,

and everything's

 in order,

Then I'll plan on

 comin' home.

 —Phil Kennington

BUCKAROO

BONUS

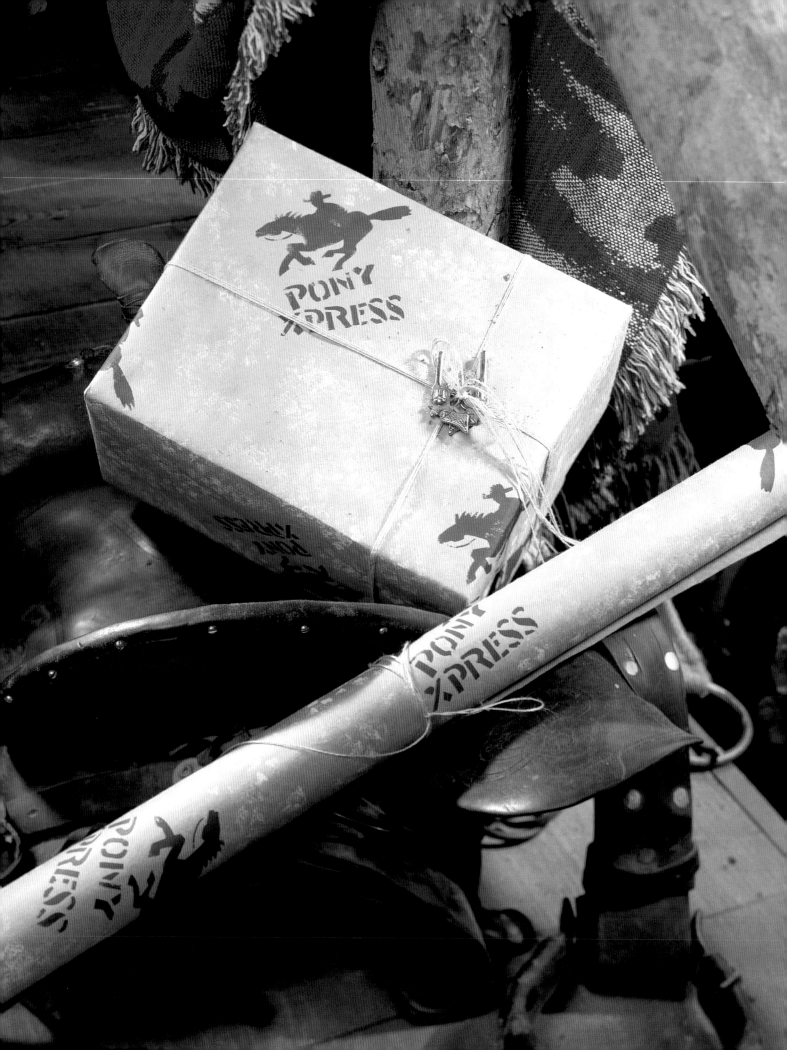

PONY EXPRESS
WRAPPING PAPER

Your gift will get there faster wrapped in this unique hand-stenciled paper! Size the pattern on a copy machine to decorate a whole saddlebag full of things. Gussy up lampshades, napkins, place mats and shirts. Need a letter holder box? Stencil the pattern on a wooden or cardboard box.

MATERIALS

Pencil and tracing paper
Manila folder
Craft knife
Large sheet of brown paper
Masking tape
Acrylic paints: dark brown and tan
Stencil brush
Small sponge

DIRECTIONS

1. Trace stencil pattern. Transfer to manila folder. Using craft knife, cut out areas to be stenciled.

2. Tape edges of brown paper to work surface so that paper lies flat.

3. Using dark brown paint, stencil rider and lettering as desired on brown paper. For an old-time effect, press a paper towel to wet stencil and carefully peel off. Allow one stencil to dry before painting another.

4. Dip edge of sponge in tan paint. Dab in random background pattern around rider and lettering. Allow to dry.

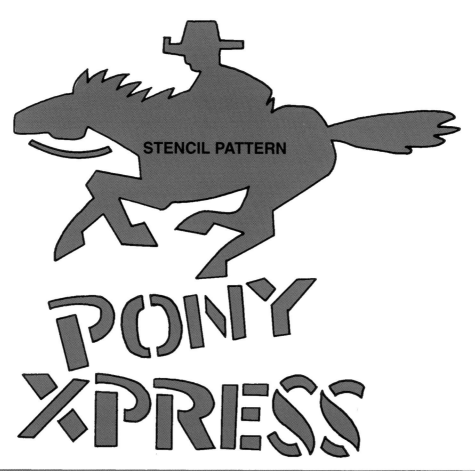

STENCIL PATTERN

PONY XPRESS

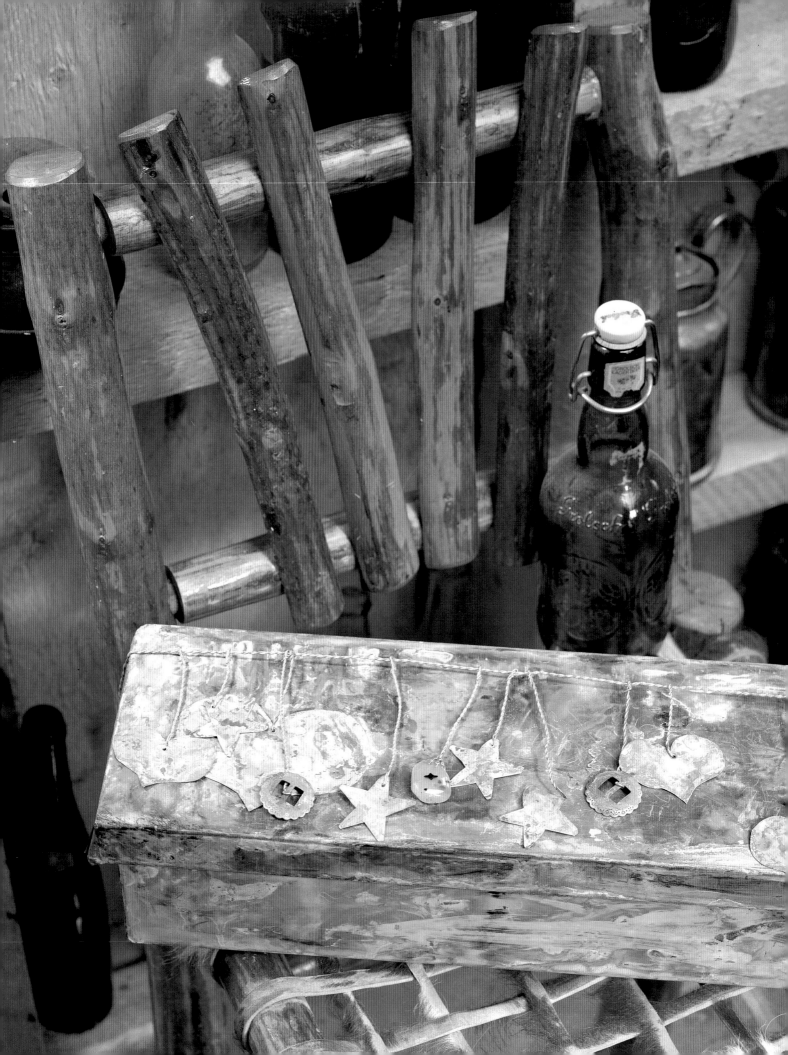

POSSIBLES BOX

MATERIALS

One purchased 5½" wide x 20" long x 4½" high
 wood box with lid
Two rolls of 12" x 36"–long 36-gauge tooling copper
One spool of 24-gauge copper wire
Three copper conchos
Two polished rock charms
Brush-on metal patina
Paintbrush
Finishing nails
Sturdy scissors
Hammer and nail

DIRECTIONS

1. Make patterns. From copper, cut seven stars, four small hearts and one large heart. Also from copper, cut one 12" x 29" piece and one 9½" x 24" piece. From wire, cut one 50" length and 17 varying lengths for hanging copper patterns.

2. Center box on large piece of copper. Measure short end of box and cut slits in short edges of copper to match box end size. Fold long edges of copper up and over top long edge of box, folding excess around to short end of box. Fold short edges of copper up and over excess; nail in place. Repeat process with lid.

3. Using hammer and nail, punch one hole at center top of each star and heart. Cut one 50" length of wire. Fold wire in half and twist; set aside. Cut 14 varied lengths of wire. String one star onto a length of wire. With star at center of length, fold length in half and twist. Repeat with remaining stars, hearts, conchos, and rocks. Twist each length to 50" length of wire at varying intervals. Lay long wire across top long edge of lid; fold ends under and tack in place with nails if necessary; see photo.

4. Following manufacturer's instructions, brush metal patina over all copper surfaces.

STAR PATTERN

SMALL HEART PATTERN

LARGE HEART PATTERN

MUSTANG PLANTER

This good-looking pony is made-to-order for a city ranch! Use it to display small potted plants or hold mail. To showcase a different breed, paint your pony accordingly: brown with black legs, black and white all over, tan with spots on the rear or whatever you prefer. Your corral will be stocked!

MATERIALS

Pencil and tracing paper
Graphite paper
18" x 34" x ¾" piece of pine
Six 8" x 1¼" x ⅜" furring strips
Scroll saw
Drill with ¼" bit
Wood glue
1¼" finishing nails
Hammer
Acrylic paints: honey gold, black, white, purple, blue, and orange
Paintbrushes
Medium sandpaper
Hot glue gun and glue sticks

DIRECTIONS

1. Enlarge/trace patterns, transferring all information. Using graphite paper, transfer front, rear and head, and tail patterns to pine. Using scroll saw, cut out. Cut out slot in front and rear piece according to pattern. From remaining pine, cut a 4" x 8" piece for planter bottom.

2. Glue front and rear pieces to planter bottom with lower edges of bottom about ½" above top of openings between front and rear legs. Secure pieces with three finishing nails at each end. Allow to dry.

3. Glue pine furring strip in place on each side of planter between front and rear pieces and level with upper edge of planter bottom. Glue second furring strip on each side about ¼" above first strips. Glue remaining furring strips on each side ¼" above second strips. Secure strips with one finishing nail at each end. Glue head into slot in front piece. Glue tail into slot in rear piece. Allow to dry.

4. Paint planter with honey gold. Allow to dry. Paint eyes and nostrils with black and blaze on face with white. Paint body as desired. Allow to dry. Lightly sand edges of wood for antique look.

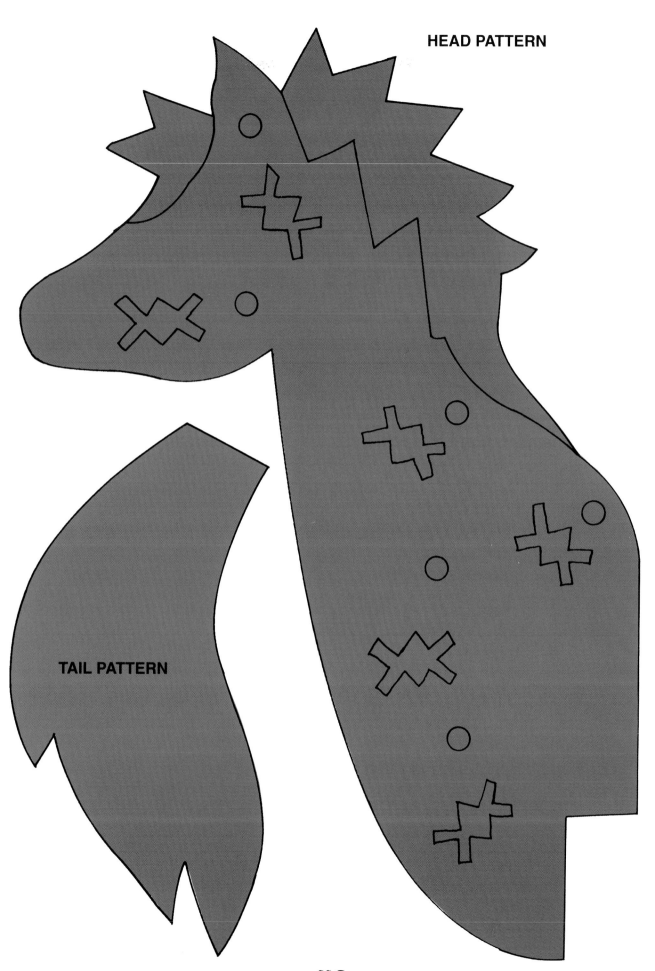

HEAD PATTERN

TAIL PATTERN

116

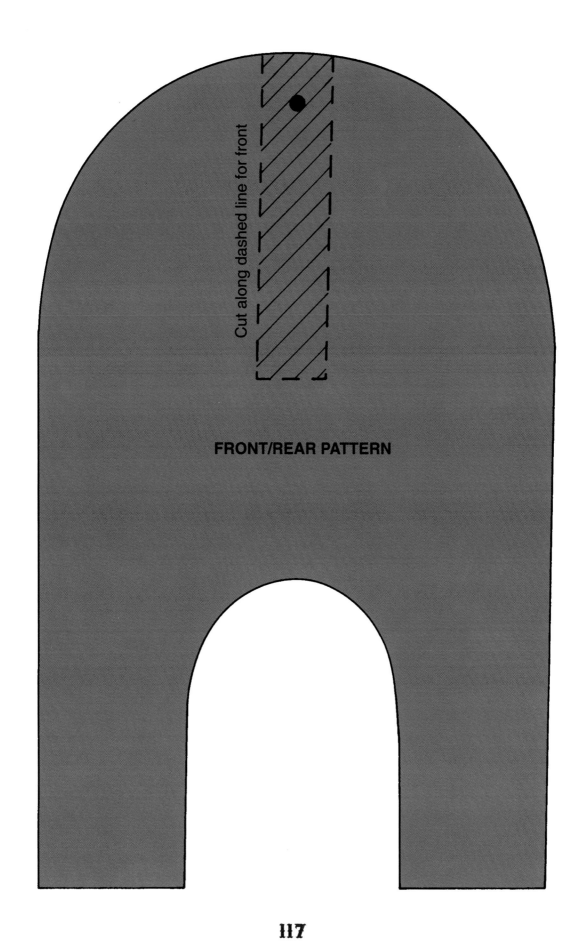

Cut along dashed line for front

FRONT/REAR PATTERN

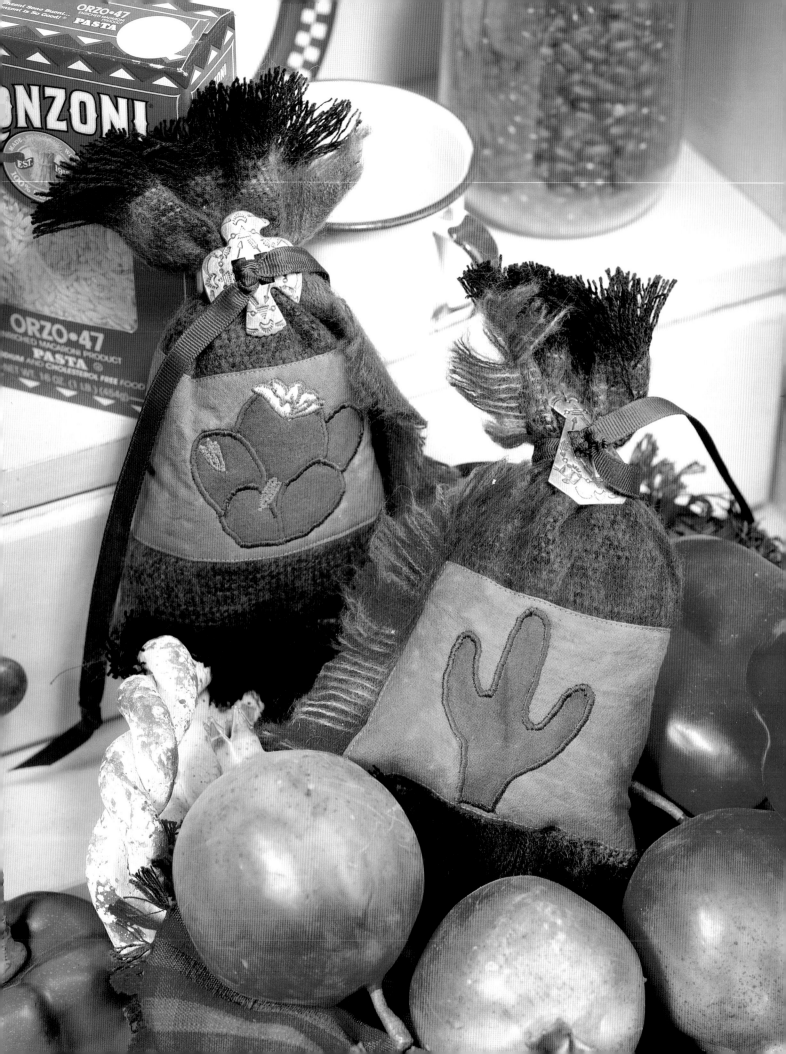

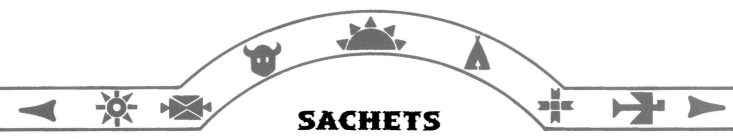
MATERIALS (for one)

11" x 11" piece of wool fabric; matching thread
⅛ yard of orange fabric; matching thread
Green fabric scraps; matching thread
White fabric scrap; pink thread
Scraps of fusible webbing
3" x 5" piece of tear-away
27" of brown grosgrain ribbon
One metal buckle
Pencil and tracing paper

DIRECTIONS (for one)
All seams are ¼".

1. Fuse webbing to wrong side of fabric scraps. Make cactus and flower patterns. From green fabric, cut one of each pattern; set aside.

2. Cut a 11" square from wool fabric. Fringe 1" on all edges. Cut a 3" x 9½" piece of orange fabric. Turn all edges of orange fabric piece under ¼"; press. With long edge of orange fabric 2" from fringe on bottom edge of wool piece and short edges of orange fabric piece aligned with unfringed sides of wool piece, topstitch.

3. Arrange cactus and flower pieces centered vertically on right half of orange/wool piece. Fuse pieces to orange/wool piece. Place shiny side of tear-away on wrong side of orange/wool piece. Iron. Satin-stitch all green edges with green thread. Satin-stitch edges of flowers pink; see photo.

4. To remove tear-away, make a small scissor cut in portion of tear-away backing appliqués. Lift and tear.

5. With wrong sides facing, topstitch bottom and side edges of orange/wool piece together making a bag. Fill bag with potpourri; see Woodland Blend Recipe on page 104.

6. Thread one end of ribbon through one hole in decorative metal buckle. Wrap ribbon around top of bag, threading end through remaining hole in buckle. Knot ribbon at center of buckle. Knot ribbon ends to prevent raveling.

FLOWER PATTERN

CACTUS PATTERNS

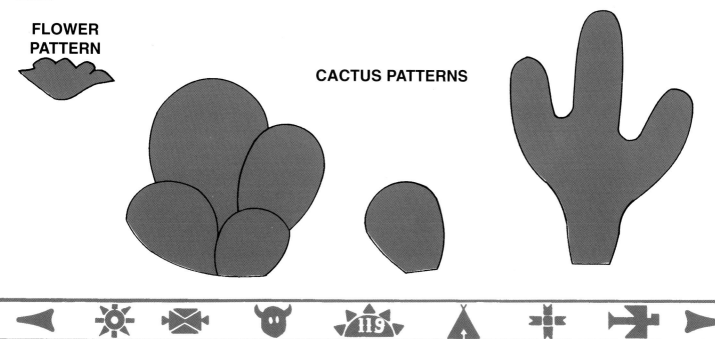

PRICKLY NOTE CARDS

These note cards are quick and easy and you can make 'em any size you need. Use 'em for gift tags, too! Add color with colored pencils or markers, if you like.

MATERIALS
Sheet of plain white paper
Pencil and ruler
Sheet of stationery
Copy machine
Purchased envelopes
8 to 12 small dried flowers per card
Glue

DIRECTIONS

1. On copy machine, reduce or enlarge cactus pattern to desired size. Cut out, leaving white space around design.

2. Run stationery through copy machine, copying cactus drawing in place.

3. Cut stationery to desired size. Glue dried flowers to card, creating cactus blossoms. Score and fold cards.

4. Write a real nice note, insert card in envelope and present to a friend!

"A Friend Is Somebody Who Knows All About You, But Likes You Anyhow."
—*Anon.*

CACTUS PATTERN

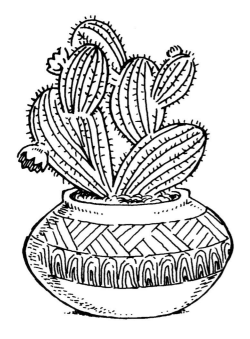

CANOES

MATERIALS

Three 8½" x 11" pieces of lightweight cardboard
Six 8½" x 11" pieces of heavy construction paper in three different colors
9 yards of 1/16" ultra-suede yarn
Two 20"-long twigs, ½" diameter
Four 7½"-long twigs, ½" diameter
Six 2"-long ¼" dowels
Six small silver charms
Acrylic paints: assorted colors
Small-hole paper punch
Spray adhesive
Large-eyed needle
Glue
Clear plastic thread
Photocopy machine

DIRECTIONS

1. Using a photocopy machine, enlarge canoe pattern (on page 124) 25%. From cardboard, cut six canoes. From each color of construction paper, cut four canoes.

2. Apply spray adhesive to one side of one cardboard canoe; adhere to construction paper canoe. Press firmly, securing all edges. Repeat for other side. Repeat again with remaining cardboard. On outside of one canoe piece, trace design; paint as desired. Glue silver charms in place; see photo. Let dry.

3. Using small-hole paper punch, punch holes all around canoe pieces following pattern. With wrong sides facing, lace canoe together with ultra-suede yarn along outside edges and leaving top edge open. Lace through individual top edges for finished look. Insert two dowels in each canoe to hold canoe sides open; see photo.

4. To make ladder, lay long twigs together spaced 5" apart. Starting 1½" from tops, lay short twigs horizontally at 5½" intervals. Bind twigs together at joints in a criss cross pattern with ultra-suede yarn. Knot. To make hanger, tie ends of a 5" length of ultra-suede yarn around top horizontal twig; see photo.

5. Attach canoes to ladder with clear plastic thread.

DESIGN PATTERN

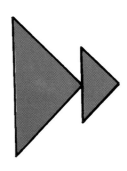

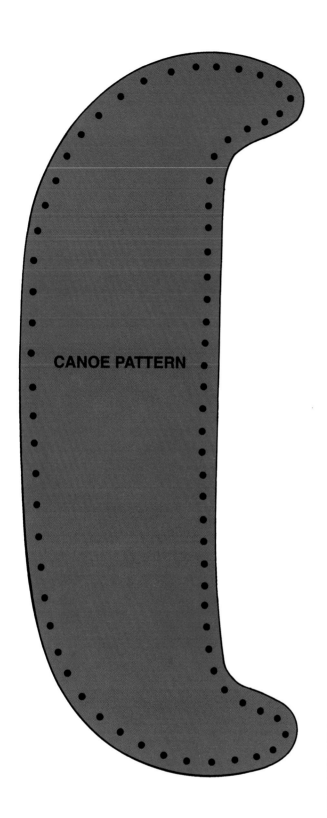

CANOE PATTERN

TEPEE PATTERN
(Instructions for tepee are on page 126.)

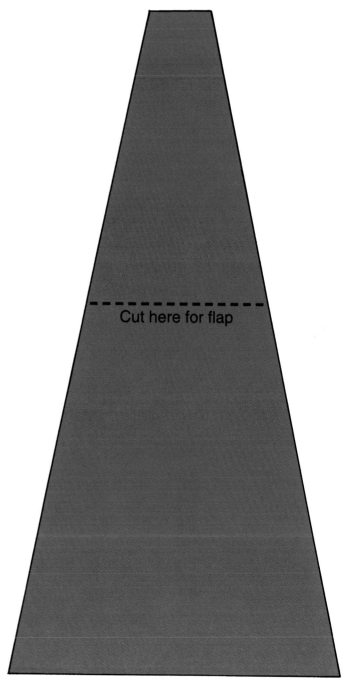

Cut here for flap

124

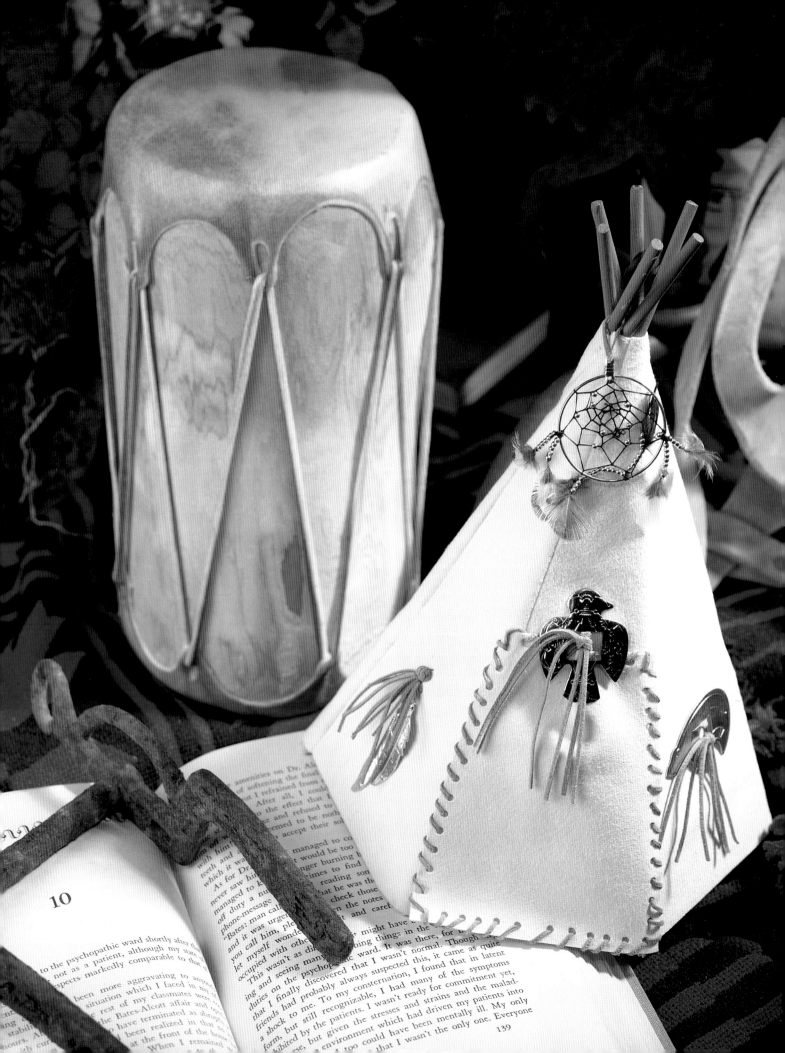

TEPEE

MATERIALS

¼ yard ultra-suede
Two 36"-long ¼" dowels
1 yard of ¹⁄₁₆" ultra-suede yarn
One eagle concho
One bear concho
Three silver feather charms
One 1" gold-tone metal ring for dream catcher
One 5" plastic ring
50 gold 11/0 plastic beads
Four small feathers
Black button twist thread
Brown paint
Paintbrush
Small-hole paper punch
Large-eyed needle
Glue
Photocopy machine

DIRECTIONS
All seams are ⅛".

1. Using photocopy machine, enlarge tepee pattern (on page 124) 25%. From ultra-suede, cut six tepees and one flap. From dowels, cut six 12" sticks. Paint 3" on one end of each dowel brown. Let dry; set aside.

2. With wrong sides together and edges aligned, stitch two tepee pieces together along one long edge. Continue stitching tepee pieces until all six are stitched together. Stitch first and sixth pieces together to form a cylinder. Turn wrong side out. Stitch casings for dowels by stitching a ⅜" seam along each existing seam. Turn right side out.

3. Insert dowels into pockets with painted ends extending out through the top. Tack plastic ring to inside of tepee to stabilize.

4. Punch small holes around entire outer edge of flap piece. Thread yarn through needle and lace yarn around flap piece through holes. Glue top and right side edges of flap to tepee; see photo.

5. To make dream catcher, cut one 3" length from ultra-suede yarn. Tie to 1" metal ring forming a hanging loop. To make web, using black button twist thread, tie one end to ring. Proceed around hoop, tying half-hitches at evenly spaced intervals. This will form loops; see Diagram A. Make spaces between half-hitches large or small, keeping in mind that the smaller the spaces the more intricate the finished web will be and add gold beads as desired, while tying half-hitches. Keep thread pulled snug. NOTE: Space between last half-hitch and starting point should be less than other spaces to keep a gap from forming between loops. Tie next half-hitch in center of first loop formed.

6. Continue tying from loop to loop, pulling snug, until opening at center of web is as small as desired. Tie off in a knot; see Diagram B. Apply a small spot of glue if necessary.

7. Using thread, string beads and feathers at varying lengths and tie to ring; see photo.

8. Using ultra-suede yarn, tie conchos and feather charms to tepee as desired; see photo. Hang dream catcher from dowel at top of tepee.

DIAGRAM A **DIAGRAM B**

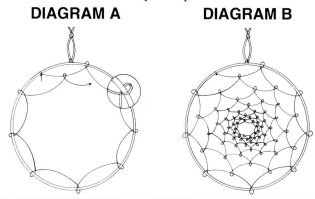

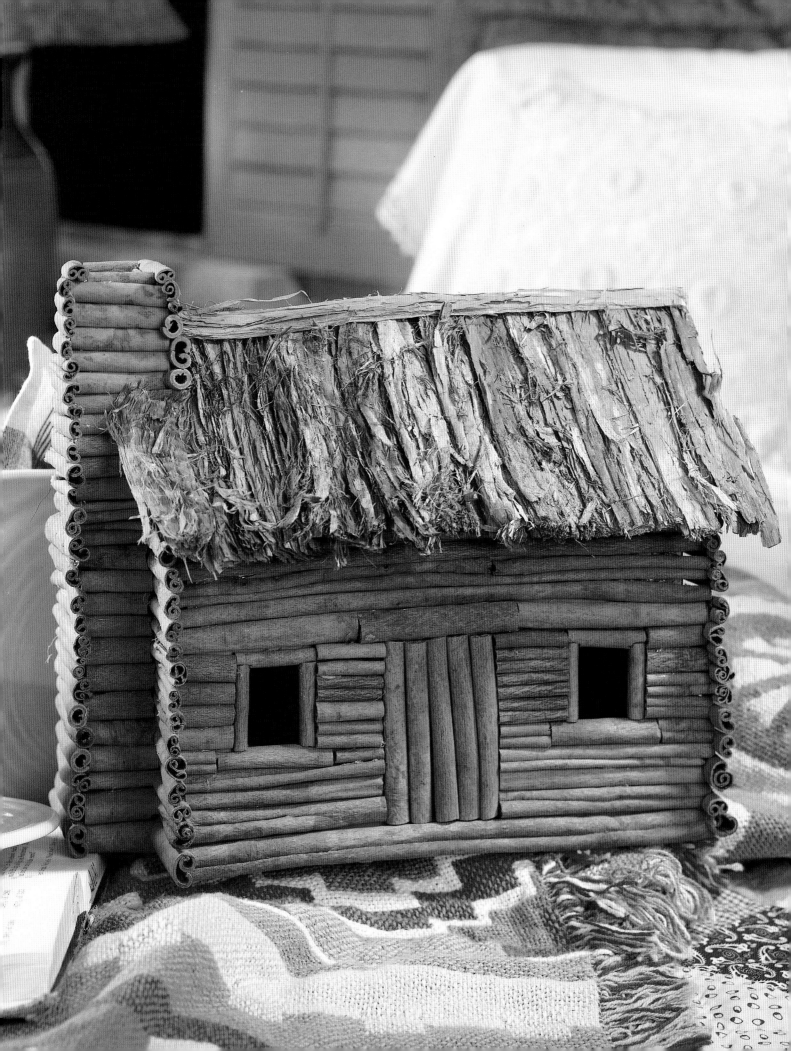

LOG CABIN

MATERIALS

23" x 28" sheet of corrugated cardboard
120 cinnamon sticks, 18"-long
Cedar bark from one log
Hot glue gun and glue
Photocopy machine

DIRECTIONS

1. Using photocopy machine, enlarge all patterns 25%. From cardboard, cut one front, one back, two sides, one roof, and one chimney. Glue front, back, and sides together.

2. Measure sides and cut cinnamon sticks, tapering on each side to match point under the roof. Glue sticks together, stacking them like a log house. Measure back of house and cut cinnamon sticks, extending ends by ¼". Glue sticks together as on sides. To make front, measure and cut cinnamon sticks to frame windows and door; see photo. Cut cinnamon sticks to fill in remaining front of house and door; glue. Measure and cut cinnamon sticks to cover chimney; glue.

3. To make roof, glue cardboard on top of framed house. Strip bark from cedar log. Glue bark to roof, trimming to fit surface. Glue strip of bark along top peak; see photo. Glue chimney on top of roof.

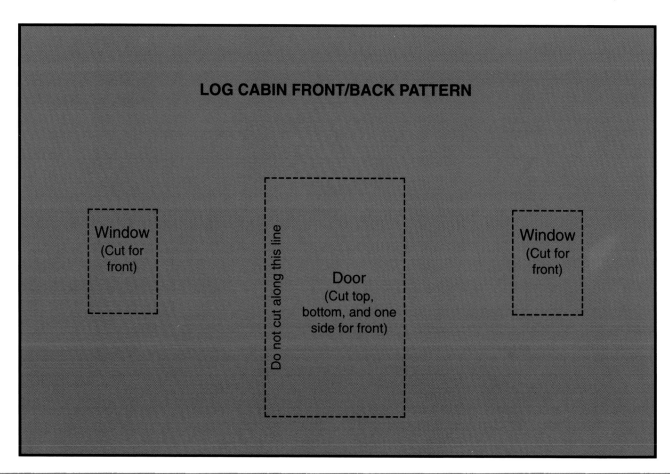

LOG CABIN FRONT/BACK PATTERN

Window (Cut for front)

Do not cut along this line

Door (Cut top, bottom, and one side for front)

Window (Cut for front)

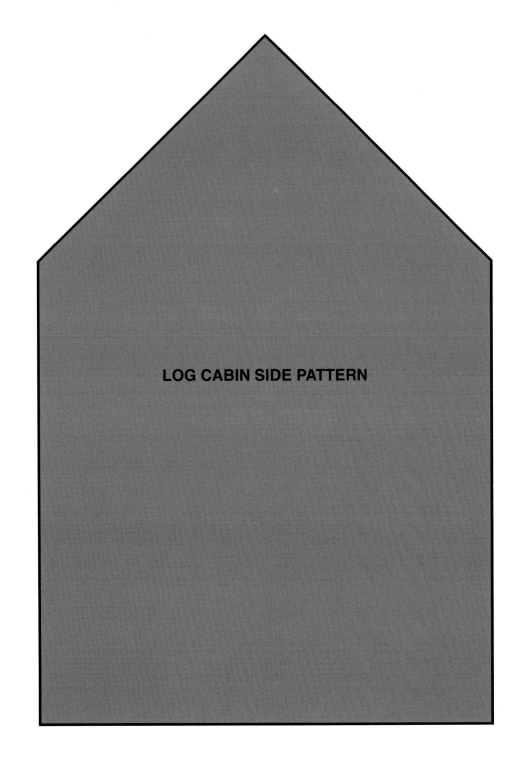

LOG CABIN SIDE PATTERN

LOG CABIN CHIMNEY PATTERN
(Fold on dotted lines)

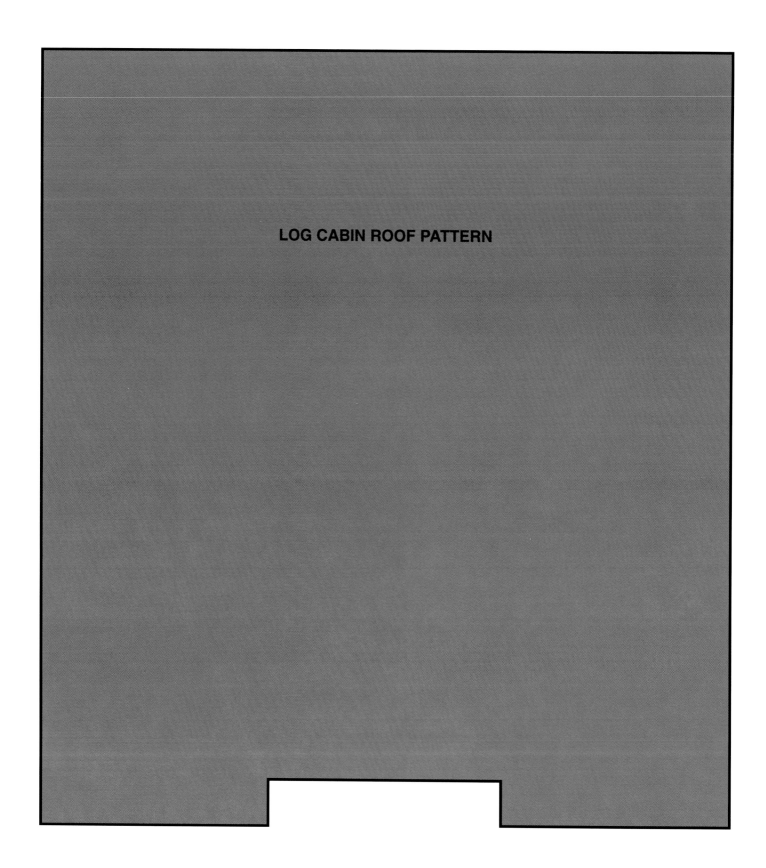

LOG CABIN ROOF PATTERN

SNAKES

MATERIALS

1" x 12" x 48" white pine wood
Acrylic paint: assorted colors
Walnut stain
Jigsaw
Paintbrush
Rags
Three saw-tooth wall hangers
Hammer and ½" nails
Pencil and tracing paper
Photocopy machine

DIRECTIONS

1. Using photocopy machine, enlarge snake pattern 25%. Match squares to complete pattern. Using jigsaw, cut three snakes from wood.

2. Using acrylic paint, paint snakes as desired; see photo. Brush on walnut stain, covering entire snake; quickly wipe off using rags.

3. Find center back of snake. Nail wall hanger in place. Repeat on remaining snakes.

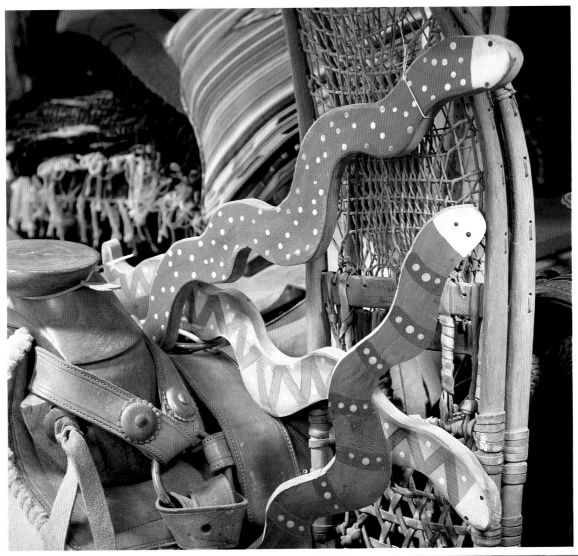

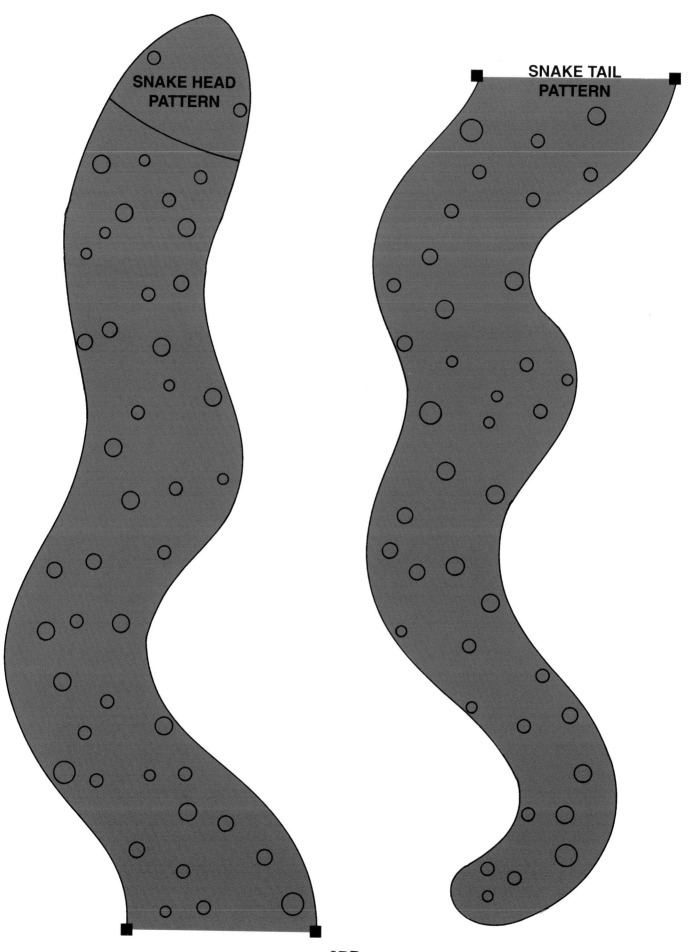

SNAKE HEAD
PATTERN

SNAKE TAIL
PATTERN

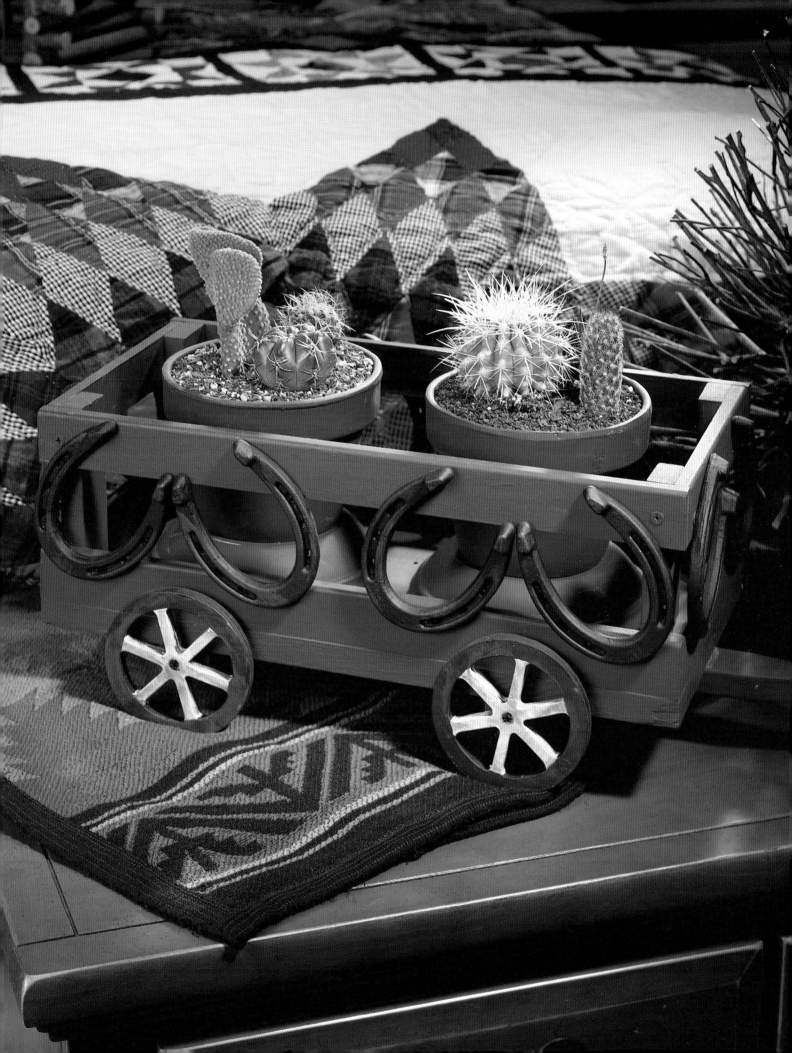

WAGON PLANTER

MATERIALS

10" x 48" x ½" length of pine wood
10" x 12" x 1" length of pine wood
Ten size 000H pony shoes
40 screws
One ½" nut and two ½" washers
Five ½" bolts
Tacks
Acrylic paints: black, brown, white, and red
Wood glue
Drill and ½" bit
Photocopy machine

DIRECTIONS

1. Using a photocopy machine, enlarge handle and wheel patterns 25%. From ½" wood, cut one 9½" x 17¾" piece for bottom, four 1½" x 17¾" strips for side running boards, two 1½" x 8¼" strips for end running boards, one handle, and four wheels. From 1" wood, cut four 1½" x 5¼" strips for inside supports and two 1½" x 9¼" strips for wheel supports.

2. Using bottom piece and two long running boards and aligning long edges, stand and glue running board strips upright. Insert short running board strips upright at each end and glue. Glue four inside supports to each inside corner against running board strips. Let dry. Screw joints on underside of wagon for support. Glue and screw remaining running board strips in place along top outer edge of inside supports; see photo. Glue and screw two wheel supports to bottom of wagon.

3. To attach handle, drill through wagon bottom and handle end. Secure with bolt, washer, handle, washer, and nut in that order.

4. Paint entire wagon red; let dry. Wash with brown, wiping excess with rag. Let dry.

5. Paint horseshoes black; let dry. Nail horseshoes to sides of wagon with tacks; see photo.

6. Paint wagon wheels black and spokes white; let dry. Wash wheels with brown, wiping excess paint with rag. Let dry.

7. Drill hole in center of each wheel. Screw in place in this order: wheel, nut, to wagon sides.

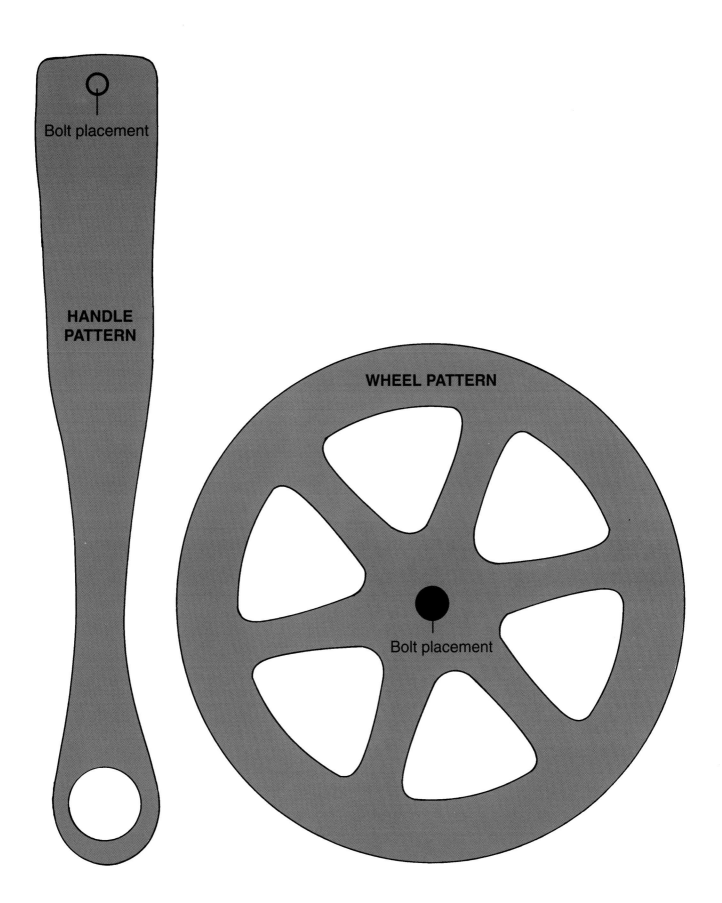

HANDLE PATTERN

Bolt placement

WHEEL PATTERN

Bolt placement

MAVERICK MAGNETS

MATERIALS

Sculpting clay
Leather stamps: assorted designs
Acrylic paints: tan and brown
Five ¾"-diameter magnets
Hot glue gun and glue

DIRECTIONS

1. From clay, make five 1½" squares ¼" thick. Find center of each square and press with desired stamp. Bake in oven at 200°F for 20 minutes. Remove from oven; let dry completely.

2. Paint all surfaces with tan acrylic paint; let dry. Wash with brown paint, wiping off excess with rag; let dry.

3. Glue magnets to back.

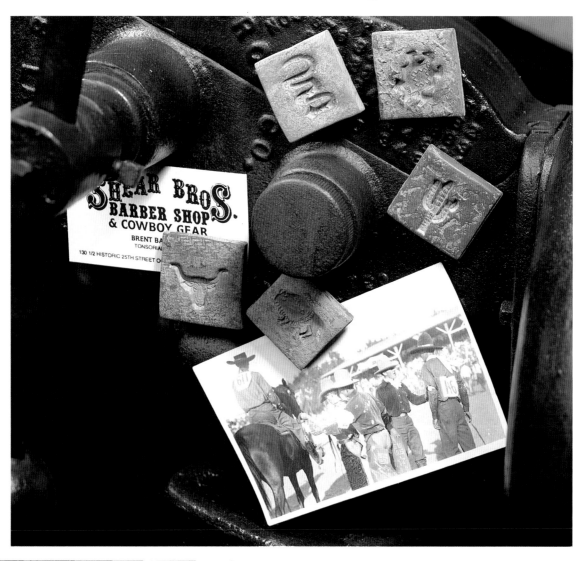

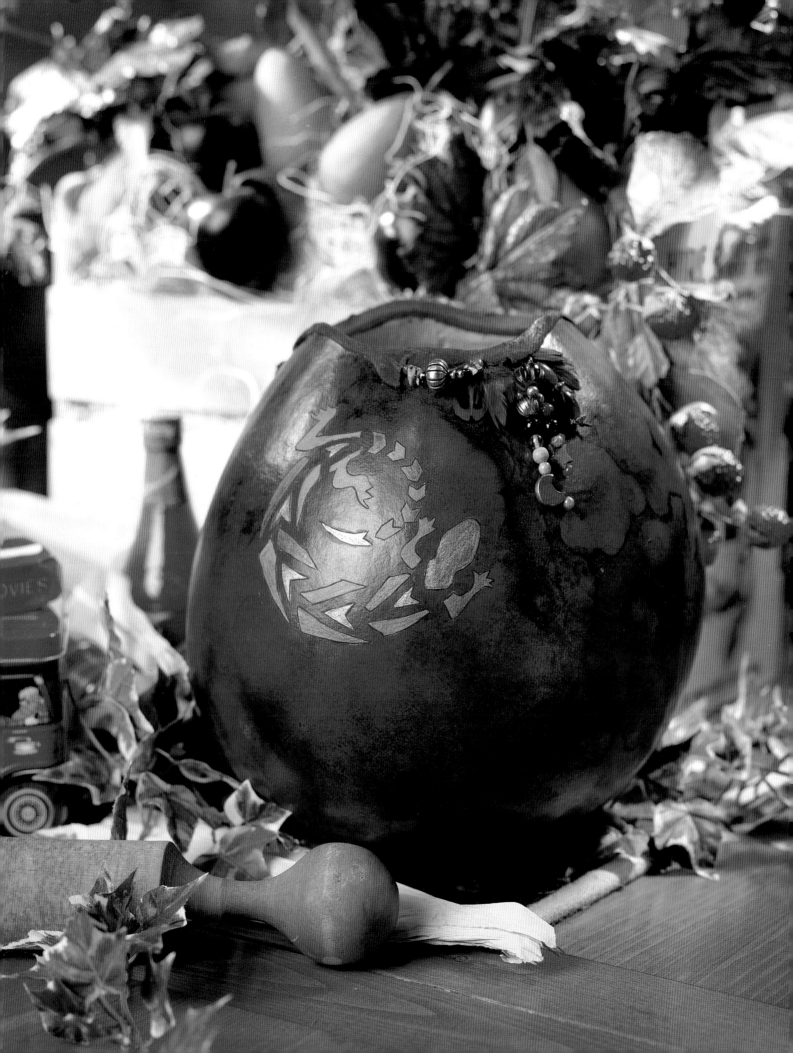

GOURD

MATERIALS

One large gourd
Black sprit dye for leather
Red spirit dye for leather
Acrylic spray lacquer
Acrylic paints: assorted colors
Scrap piece of leather
Small feathers
Assorted beads
Drill
Jigsaw
Glue
Fine-line black permanent marker
Pencil and tracing paper
Manila folder

DIRECTIONS

1. Draw line on top of gourd the desired size for opening. Using drill, drill a hole large enough that jig-saw blade will fit through. Cut hole using jig-saw; hole should not be perfectly straight. Stretch and glue leather scrap around edge of hole.

2. Dye the inside of the gourd with black dye. Cover outer surface of gourd and leather strip with red dye. Overdye with black, allowing colors to bleed. Let dry about 24 hours.

3. Trace lizard pattern. Transfer to manila folder. Cut out areas to be stenciled. Stencil lizard using several different colors; let dry. Outline lizard using fine-line permanent marker. Let dry. Spray entire surface with lacquer.

4. Glue feather in cluster to the right of lizard by leather; see photo. String beads and attach to gourd by feathers; see photo.

LIZARD PATTERN

OLD GLORY CHAIR

Flag Chair
MATERIALS

One ladder-back chair with slated seat
Two large wooden stars
One large wooden heart
Primer
Acrylic paints: red, white, and blue
Paintbrushes
Medium sandpaper
Wood glue

DIRECTIONS

1. Paint entire chair with primer. Let dry about four hours. Paint slats of seat, alternating red and white. Paint chair back blue; see photo. Let dry completely. Lightly sand edges of wood for antique look.

2. Paint stars and heart white; let dry completely. Wash stars with blue paint and heart with red paint. Let dry. Glue to chair back; see photo.

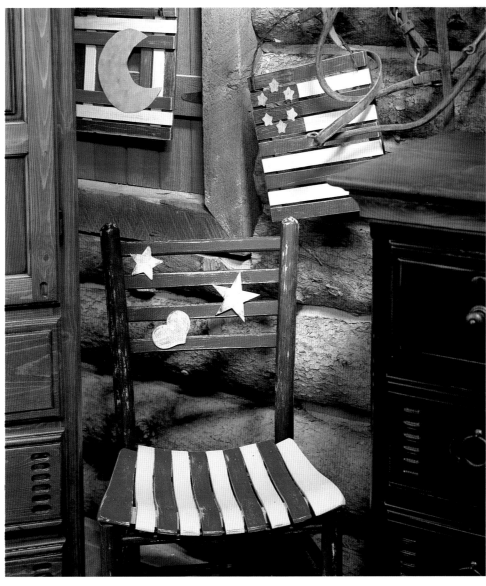

PATRIOTIC WALL HANGIN'S

Moon Wall Hanging
MATERIALS

One 12" square of pine wood, ¼" thick
One 12" square piece of 36-gauge copper
18" length of old barbed wire
Acrylic paints: red, white, blue, yellow, and gold
Small nails
Paintbrush
Sturdy scissors
Electric saw
Medium sandpaper

Flag Wall Hanging
MATERIALS

One 12" square of pine wood, ¼" thick
One 5" square piece of 36-gauge copper
18" length of old barbed wire
Acrylic paints: red, white, blue, and gold
Small nails
Paintbrush
Sturdy scissors
Electric saw
Medium sandpaper

DIRECTIONS

1. Make moon and star patterns. From copper, cut one moon and six stars. From wood, cut 11 strips, 1"-wide for flag and 12 strips 1"-wide for moon.

2. To make moon wall hanging, paint four strips white, four strips blue, and four strips red. Let dry. Stress with sandpaper.

3. Lay one blue, one white and one red strip ¼" apart, space 4" and lay one red, one white and one blue strip ¼" apart vertically. Horizontally, start at top aligning edges, lay one blue, one white, and one red strip ¼" apart, space 4" and lay one red, one white, and one blue strip ¼" apart. Tack in place with small nails.

4. Paint moon with yellow and gold paint, allowing copper to show through. Tack to center of wall hanging.

5. Attach barbed wire through opening at top between blue and white strips, bending wire back and around to hold in place; see photo.

6. To make flag, paint three strips red, three strips white, and two strips blue. Paint 7" of two strips red, remaining 5" blue and 7" of two strips white, remaining 5" blue. Let dry. Stress with sandpaper.

7. Starting at top alternate blue/red and blue/white strips and then red and white strips ¼" apart. Turn over and nail one blue strip, aligning edges vertically on each edge of flag.

8. Paint stars with yellow and gold paint, allowing copper to show through. Tack in a circle on blue square; see photo. Attach barbed wire as above.

CROSS-STITCH TIPS

FABRICS: Counted cross-stitch is usually worked on even-weave fabric. These fabrics are manufactured specifically for counted-thread embroidery and are woven with the same number of vertical as horizontal threads per inch. Because the number of threads in the fabric is equal in each direction, each stitch will be the same size. It is the number of threads per inch in even-weave fabrics that determines the size of a finished design.

PREPARING FABRIC: Cut even-weave fabric at least 3" larger on all sides than the design size, or cut it the size specified in the instructions. A 3" margin is the minimum amount of space that allows for comfortably working the edges of the design. To prevent fraying, whipstitch or machine-zigzag raw fabric edges.

NEEDLES: Needles should slip easily through the holes in the fabric but not pierce the fabric. Use a blunt tapestry needle, size 24 or 26. Never leave the needle in the design area of your work. It can leave rust or a permanent impression on the fabric.

FLOSS: All numbers and color names are cross-referenced between Anchor and DMC brands of floss. Run the floss over a damp sponge to straighten. Separate all six strands and use the number of strands called for in the code.

SECURING THE FLOSS: Insert your needle up from the underside of the fabric at your starting point. Hold 1" of thread behind the fabric and stitch over it, securing it with the first few stitches. To finish thread, run under four or more stitches on the back of the design. Never knot floss unless working on clothing. Another method of securing floss is the waste knot. Knot your floss and insert your needle from the right side of the fabric about 1" from the design area. Work several stitches over the thread to secure. Cut off the knot later.

STITCHING METHOD: For a smooth cross-stitch, use the "push-and-pull" method. Starting on wrong side of fabric, bring needle straight up, pulling floss completely through to right side. Reinsert needle and bring it back straight down, pulling needle and floss completely through to back of fabric. Keep floss flat but do not pull thread tight. Consistent tension throughout ensures even stitches. Make one stitch for every symbol on the chart. To stitch in rows, work from left to right and then back. Half-crosses are used to make a rounded shape. Make the longer stitch in the direction of the slanted line.

CROSS-STITCH: Make one cross-stitch for each symbol on chart. Bring needle up at A, down at B, up at C, down at D; see diagram. For rows, stitch across fabric from left to right to make half-crosses and then back to complete stitches. All stitches should lie in the same direction.

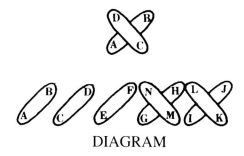

DIAGRAM

WORKING WITH METAL

EMBOSSING: Emboss patterns before cutting them out. Trace the embossing pattern onto a piece of tracing paper. Tape the paper in the appropriate place on the metal to be embossed. Place the metal on a stack of paper. Using a tin tool, ballpoint pen or pencil, trace the pattern on the metal. Indented embossing is achieved by tracing the pattern on the right side of the metal. Raised embossing is achieved by tracing the pattern on the wrong side of the metal. Tracing the pattern several times will create a deeper line and will make the detail stand out more.

SOLDERING: Resin core solder is used in all projects requiring solder. All soldering must be done before painting or finishing. Touch the iron to the spot on the metal to be soldered and then touch the solder to the hot spot on the metal.

STEEL WOOL: It is a good idea to clean all projects with steel wool before antiquing or painting. This will remove any dirt or oil from your hands that could be present on the surface of the metal. For projects that are not antiqued or painted, gently polish the surface to restore the metal's original luster. Also use steel wool to clean a metal surface that has been tarnished from soldering.

SEWING TIPS

PATTERNS: Use tracing paper to trace patterns. Be sure to transfer all information. All patterns include seam allowances unless otherwise specified. The seam allowance is ¼" unless otherwise specified.

MARKING ON FABRIC: Always use a dressmaker's pen or chalk to mark on fabric. It will wash out when you clean your finished piece.

SLIPSTITCH: Insert needle at A, taking a small stitch, and slide it through the folded edge of the fabric about ⅛" to ¼", bringing it out at B.

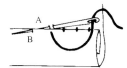

BIAS STRIPS: Bias strips are used for ruffles, binding, or corded piping. To cut bias, fold the fabric at a 45° angle to the grain of the fabric and crease. Cut on the crease. Cut additional strips the width indicated in the instructions and parallel to the first cutting line. The ends of the bias strips should be on the grain of the fabric. Place the right sides of the ends together and stitch with a ¼" seam. Continue to piece the strips until they are the length that is indicated in the instructions.

CORDED PIPING: Center cording on the wrong side of the bias strip and fold the fabric over it, aligning raw edges. Using a zipper foot, stitch through both layers of fabric close to the cording. Trim the seam allowance to ¼".

MITERING A CORNER: Sew border strips up to but not through the seam allowance; backstitch. Repeat on all four edges, making stitching lines meet exactly at the corners. Fold two adjacent border pieces together. Mark; then stitch at a 45° angle. Trim seam allowance to ¼".

SEWING BEADS: For small areas and tight curves, it is best to sew on each bead individually. Bring the needle up from back to front through the beading surface in the desired location. Slip the bead over the needle and guide it all the way down the thread until it rests on the beading surface in the desired place. Bring the needle back through the beading surface right in the same hole or very close by so that the bead is secured to the surface.

COUCHING: Couching is a sewing technique used to anchor objects to any surface. With thread, bring the needle up at A, down at B. Repeat to attach the entire length as desired.

METRIC EQUIVALENCE CHART

MM-Millimetres CM-Centimetres

INCHES TO MILLIMETRES AND CENTIMETRES

INCHES	MM	CM	INCHES	CM	INCHES	CM
⅛	3	0.3	9	22.9	30	76.2
¼	6	0.6	10	25.4	31	78.7
⅜	10	1.0	11	27.9	32	81.3
½	13	1.3	12	30.5	33	83.8
⅝	16	1.6	13	33.0	34	86.4
¾	19	1.9	14	35.6	35	88.9
⅞	22	2.2	15	38.1	36	91.4
1	25	2.5	16	40.6	37	94.0
1¼	32	3.2	17	43.2	38	96.5
1½	38	3.8	18	45.7	39	99.1
1¾	44	4.4	19	48.3	40	101.6
2	51	5.1	20	50.8	41	104.1
2½	64	6.4	21	53.3	42	106.7
3	76	7.6	22	55.9	43	109.2
3½	89	8.9	23	58.4	44	111.8
4	102	10.2	24	61.0	45	114.3
4½	114	11.4	25	63.5	46	116.8
5	127	12.7	26	66.0	47	119.4
6	152	15.2	27	68.6	48	121.9
7	178	17.8	28	71.1	49	124.5
8	203	20.3	29	73.7	50	127.0

YARDS TO METRES

YARDS	METRES	YARDS	METRES	YARDS	METRES	YARDS	METRES	YARDS	METRES
⅛	0.11	2⅛	1.94	4⅛	3.77	6⅛	5.60	8⅛	7.43
¼	0.23	2¼	2.06	4¼	3.89	6¼	5.72	8¼	7.54
⅜	0.34	2⅜	2.17	4⅜	4.00	6⅜	5.83	8⅜	7.66
½	0.46	2½	2.29	4½	4.11	6½	5.94	8½	7.77
⅝	0.57	2⅝	2.40	4⅝	4.23	6⅝	6.06	8⅝	7.89
¾	0.69	2¾	2.51	4¾	4.34	6¾	6.17	8¾	8.00
⅞	0.80	2⅞	2.63	4⅞	4.46	6⅞	6.29	8⅞	8.12
1	0.91	3	2.74	5	4.57	7	6.40	9	8.23
1⅛	1.03	3⅛	2.86	5⅛	4.69	7⅛	6.52	9⅛	8.34
1¼	1.14	3¼	2.97	5¼	4.80	7¼	6.63	9¼	8.46
1⅜	1.26	3⅜	3.09	5⅜	4.91	7⅜	6.74	9⅜	8.57
1½	1.37	3½	3.20	5½	5.03	7½	6.86	9½	8.69
1⅝	1.49	3⅝	3.31	5⅝	5.14	7⅝	6.97	9⅝	8.80
1¾	1.60	3¾	3.43	5¾	5.26	7¾	7.09	9¾	8.92
1⅞	1.71	3⅞	3.54	5⅞	5.37	7⅞	7.20	9⅞	9.03
2	1.83	4	3.66	6	5.49	8	7.32	10	9.14

INDEX

Bandanna Window Valance56
Beaded Denim Shirt11
Beaded Earrings ...27
Beaded Hatband ...25
Beaded Light Switch47
Beaded Paper Frame......................................38
Beaded Picture Pins87
Beaded Watchband..26
bias strips...142
Boot Light Switch46
Bunkhouse Bookends61
Cactus Light Switch46
Canoes ..123
Cavalry Shirt ...17
Clay Candleholders107
corded piping ..142
Corn Salsa ..104
couching ..142
Country Cupboard84
Covered Wagon Mailbox92
Cow Punchin' PJ's19
Cowboy Quilt ...86
Cross-Stitch Cowgirl73
 code ...73
 graph ..74-77
Cross-Stitch Sampler64
 code ...64
 graph ..64-67
Cross-Stitch Tips141
cross-stitch...141
Darn Good Doorstop43
Desert Flowerpots31
Desert Stenciled Shirt Pocket13
Dream Catcher..79
Fishes in Stitches ..58
 code ...58
 graph ..58-59
Frontier Picture Frame90
embossing...141
fabrics ..141
floss ...141
General Instructions141
Gourd ...138
Hang 'Em Up Coat Rack.................................53
Hot! Hot! Salsa..104
Hot! Salsa ..104
Jar Dangles ..103

Leather Jar Labels100
Li'l Boots Shelf Liner33
Lizard Light Switch......................................46
Log Cabin ..128
Longhorn Bar-B-Q Apron97
marking on fabric142
Maverick Magnets136
Mild Salsa ...104
mitering a corner142
Mustang Planter ...115
Napkin Ring ...106
needles ...141
Old Glory Chair...139
Paper Poetry Frame35
Patriotic Wall Hangin's140
patterns ..142
Place Mat...106
Pony Express Wrapping Paper...........................111
Possibles Box ..113
preparing fabric ..141
Prickly Note Cards121
Quilted Hot Pad ..72
Quilted Note Card ..71
Quilted Table Runner69
Ranch Journal ...39
Ranch Numbers ...55
Rancher Recipes ...104
Red-Pepper Door Hanger89
Rodeo Shirt Pocket14
Sachets..119
securing the floss141
Sewing Tips ..142
sewing beads ..142
Shoot-Out Shirt Pockets13
slipstitch ...142
Snakes..131
soldering ...142
Southwest Bag ...21
steel wool ..142
stitching method ..141
Sunflower Pillow ..51
Taos Light Switch Covers.................................46
Tepee ..126
Wagon Planter ...134
Western Lampshade81
Woodland Blend Potpourri Recipe104
Xmas Tree Stocking Holder...............................41